HEART OF DAR

D1490064

HEART OF DARKNESS

Kai Althoff
Ellen Gallagher and Edgar Cleijne
Thomas Hirschhorn

Philippe Vergne
Walker Art Center, Minneapolis

Published on the occasion of the exhibition *Heart of Darkness*, curated by Philippe Vergne with Yasmil Raymond for the Walker Art Center.

WALKER ART CENTER
Minneapolis, Minnesota / October 21, 2006 – January 14, 2007

The exhibition catalogue for *Heart of Darkness* is made possible by generous support from Gladstone Gallery, New York; Gagosian Gallery, New York; and a grant from the Andrew W. Mellon Foundation in support of Walker Art Center publications.

Library of Congress Cataloging-in-Publication Data

Vergne, Philippe.
 Heart of darkness : Kai Althoff, Ellen Gallagher & Edgar Cleijne, Thomas Hirschhorn / Philippe Vergne, Jane Jacobs, Jacques Rancière. -- 1st ed.
 p. cm.
 Catalog of an exhibition held at the Walker Art Center, Minneapolis.
 ISBN-13: 978-0-935640-85-4 (pbk. : alk. paper)
 ISBN-10: 0-935640-85-1 (pbk. : alk. paper)
 1. Multimedia (Art)--Exhibitions. 2. Art, Modern--21st century--Exhibitions. I. Jacobs, Jane, 1916-2006. II. Rancière, Jacques. III. Walker Art Center. IV. Title.
 N6498.M78.V47 2006
 709.05'074776549--dc22
 2006030873

DESIGNERS
Andrew Blauvelt and Chad Kloepfer

EDITORS
Pamela Johnson and Kathleen McLean

PUBLICATIONS MANAGER
Lisa Middag

PRODUCTION SPECIALIST
Greg Beckel

Printed and bound in the United States of America by Shapco Printing, Inc.

ACKNOWLEDGMENTS

An exhibition of this magnitude could not have been realized without the important contributions of many key individuals. We would like first and foremost to extend our deepest appreciation and admiration to artists Kai Althoff, Edgar Cleijne, Ellen Gallagher, and Thomas Hirschhorn, whose art and overlapping concerns helped inspire this exhibition.

Our sincere gratitude also to the lenders and to the galleries whose commitment made the exhibition possible. Special thanks to Larry Gagosian, Bob Monk, and Natasha Roje at Gagosian Gallery, New York; Barbara Gladstone, Rosalie Benitez, Maxime Falkenstein, Adam Ottavi-Schiesl, and Kimberly Lane at Gladstone Gallery, New York; and Robert Gunderman, Randy Sommer, and Dean Anes at ACME, Los Angeles. Our heartfelt thanks go to Eric Brown for assisting us with the reconfiguration of Hirschhorn's *Cavemanman*; and to Ted Lawson for guiding us in the design of Gallagher and Cleijne's *Murmur: Watery Ecstatic, Kabuki, Blizzard of White, Super Boo, Monster*.

At the Walker Art Center, we would like to thank director Kathy Halbreich for creating an institutional environment that both values the experimental and gives new meaning to the notion of civic engagement. In the Visual Arts Department, we are extremely grateful to Eileen Romain and Lynn Dierks, who deftly handled the many administrative details of the exhibition and publication, and curators Siri Engberg, Betsy Carpenter, and Doryun Chong, whose feedback and enthusiasm have been an essential contribution in the realization of the exhibition. A special thanks to curatorial fellow Nancy Meyer, who recently came on board and swiftly made valuable contributions to the catalogue and installation of the show. We also thank curators Philip Bither and Sheryl Mousley and their staff in the Performing Arts and Film/Video departments for their unfailing support of our endeavors in the galleries.

The experience that awaits visitors to the exhibition is the work of an amazing team of collaborators: registrar Elizabeth Peck, who expertly oversaw the care and safe handling of the pieces; program services director Cameron Zebrun, exhibition technicians Doc Czypinski, Phil Docken, Bob Brown, and David Dick, and the entire Program Services staff, who are talented enough to mount a show in total darkness; director Sarah Schultz, Sarah Peters, and their colleagues in the Education and Community Programs Department, who enlightened visitors with their exhibition-related programs; and Robin Dowden and her talented staff in the New Media Initiatives Department, who ensure that our message exists beyond gallery walls and printed matter.

In the Development Department, we would like to thank director Christopher Stevens, special projects director Marla Stack, and their colleagues for their unflagging efforts in making this exhibition financially possible. Thanks also go to the

Walker's fiscal caretakers, deputy director and chief operating officer Dave Steglich and chief financial officer Mary Polta; director Phillip Bahar and members of the Marketing and Public Relations Department for enthusiastically working to widen the visibility of our program in the Twin Cities; photographers Cameron Wittig and Gene Pittman; and librarian Rosemary Furtak and archivist Jill Vuchetich for their research assistance for this exhibition. Finally we are extremely grateful to the staff of the Walker's Design and Editorial Department, especially design director and curator Andrew Blauvelt and senior designer Chad Kloepfer for their tremendous creativity in the outstanding design of this publication; editors Kathleen McLean and Pamela Johnson, who oversaw with diligent attention its words; and publications manager Lisa Middag, who guided its production from start to finish.

Philippe Vergne, Chief Curator and Deputy Director
Yasmil Raymond, Assistant Curator

THE HISTORY OF FORM—THE FORM OF HISTORY
Philippe Vergne

To conclude his novel *"Exterminate All the Brutes"* (1996), Sven Lindquist wrote: "You already know that. So do I. It is not knowledge we lack. What is missing is the courage to understand what we know and draw conclusions."

Looking around, looking at every newspaper, Web site, blog, podcast, and television channel, one indeed feels a sense of vertigo from all the information and knowledge streaming constantly. We are living in—and it is an overcooked, over-chewed cliché—the age of information; we are swallowed up by a tsunami of signs, and things seem to be getting worse and worse, as if all this is merely the hyperbolic scenario of a disaster production, a worldwide spectacle providing endless drafts for the next blockbuster, for which most of us will be seated in the front row, numb, until our feet get splattered. This blockbuster might not be a comedy, but if it is, the joke might very well be on all of us, with a bitter taste of déjà-vu: the melting ice caps, the deluge, the rise of right-wing conservatism and of the extreme right across the board and across the seas, the growing power of religious fundamentalism, the spreading of intolerance, the slow normalization of the individual, the myopic individualism, the "shock and awe" as diplomatic strategy, the "see something say something" as civic-engagement model, the educational crisis, the cultivated ecology of fear, the contagion of Puritanism, the distrust of science, the progressive erosion of human rights . . . and more to come.

It is not a pretty picture, but a general anomie and apathy seem to be the rule, and anger, resistance, the striving for an alternative against the laisser faire attitude is not channeled in a visible way; the voices of intellectuals, writers, and activists are strangely muted, not because they are silent, but because the plug has been pulled. We are going through an age of consensual disenchantment, the consensus being not so much an awareness that things are bad, really bad, but the fact that the possibility of change seems remote. We are facing dark ages to come, and what is lacking might be the ability of our tools of representation to give form to or invent a form that will contain not a solution, but a way to identify the problem, to rephrase a question. We are not in an era of "by any means necessary" but in that of "by other means necessary"—an era in which the word "politics" has lost so much of its bloom that just the sound of it makes us roll our eyes. Imagine what the association of "political" and "art" could do.

If the codes of representation are altered or simply feed an industry of "nobody moves nobody gets hurt" narratives, the field of aesthetics then might have to assume a certain level of responsibility, as it is a laboratory of signs that could articulate how and what to represent. If an aesthetic regime was ever in a position to inform the ambient regime, how could a work of art, an exhibition, an artist provide

—

an aesthetic experience that would enable a different attitude toward the world? The question is not even whether art could change the world, change life. At this moment, the most intricate question is: could art actually change art? The answer to this last query carries more leverage and could provide the beginning of an answer to the first question, one way or another. This is not an elitist statement, but an awareness, an acknowledgment that it has to start somewhere. If it does not start with art, then art is doomed to become more complicit, or maybe worse, just anemic, or just art.

It is along these lines that the exhibition *Heart of Darkness* germinated, along with a desire to present art and exhibitions a bit differently, and if truth be told, with a touch of nostalgia for earlier experimentation: the 1938 *International Surrealist Exhibition* in Paris; the room conceived by Marcel Duchamp in New York in 1942 (*First Papers of Surrealism*); Lucio Fontana's project *Ambiente spaziale a luce nera* at the Naviglio Gallery in Milan in 1949; *The Void* by Yves Klein at the Iris Clert Gallery in 1958; Allan Kaprow's *8 Happenings in 6 parts* in 1959; *The Store* by Claes Oldenburg in 1961 in New York; the *Dylaby* exhibition in 1962 with Jean Tinguely and Daniel Spoerri at the Stedelijk Museum in Amsterdam; Joseph Beuys' *Exhibition in the Barn* in Kranenburg in 1963; Pino Pascali's *Serie Degli Armi* at the Gian Enzo Sperone Gallery in Turin in 1966; Niki de Saint-Phalle's *Hon (She)* installation at the Moderna Museet, Stockholm, in 1966; the *Tropicália, Penetraveis* by Hélio Oiticica in 1967; Marcel Broodthaers' *Musée d'Art Moderne, Département des Aigles* at the Düsseldorf Kunsthalle in 1972; the *Utopia Post Utopia* exhibition at the Institute of Contemporary Art in Boston in 1988. This is just a short list, with gaps, of works, exhibitions, and projects that have defied the understanding and the role of an art object as well as challenged the conception of the exhibition as a summary of objects, relics, and examples. They also define a different relationship to the materiality of art—its relationship to context and architecture and to the audience. Beyond the artists involved, beyond the time frame they belong to, beyond the cultures they have emerged from, these exhibitions all share the fact that they occurred in times of social and political crisis and had in one way or another addressed these shifts, without ever being didactic. These projects were able to articulate, in one aesthetic ellipse, both the histories of form and the forms of history. The artists involved in the *Heart of Darkness* exhibition work along lines of comparable ambition.

The exhibition borrows its title from Joseph Conrad's 1899 novel, which has been considered by some scholars to have been a powerful denunciation of the evils of imperialism, domination, and the inequities of power and wealth. It exposes the brutal repression carried out in the Congo by the Belgian colonialists in what remains one of the largest genocides to date. A very controversial literary work, *Heart of Darkness* has also been interpreted as a racist colonialist allegory in which the African continent is depicted as the land of savages and the inscrutably alien. Edward W. Said, in *Culture and Imperialism*, provides readers with a very thorough analysis of Conrad's novel. He stresses that if the author sees the horror of colonialism, his tragic limitation is his failure to envision an alternative. His virtue, nevertheless, is the novel, the ironic distance that reveals his realization that "like narrative, imperialism has monopolized the

entire system of representation."[1] By colliding historical investigation, fiction, and to a certain extent, autobiography, Conrad unfolds a form that by itself carries criticism and sows doubts about the validity of legitimizing narratives.

Kai Althoff, Ellen Gallagher and Edgar Cleijne, and Thomas Hirschhorn could be perceived along similar lines in their attempts to question an aesthetic, or at least "design" a model rather differently. Althoff's work—sculpture, photography, video, performance, music (with the band Workshop), painting, drawing, and prints— conveys a sense of ahistorical timelessness. It amalgamates, without necessarily quoting, the memories of the Vienna Secession, Egon Schiele, Symbolism, Jean Cocteau, Jack Smith, and Rainer Werner Fassbinder, among others. Through such a range of references, Althoff suggests and summons forms that are associated with ages of crisis. His work, regardless of his medium, formalizes his investigation of feelings and things and ways that the latter can express the former. He engages his audience in oblique narratives animated by erotic and fetishistic associations that defy, through aestheticized indecency, social stillness, sexual repression, and moral absolutism.

The environment/collage *Solo für eine befallene Trompete* (*Solo for an Afflicted Trumpet*) (2005) is a luscious, ravishing, saturated environment composed of found objects, Althoff's paintings, garments, boudoirlike furniture, and bohemian draperies that delineate, with a touch of flaming decadence, the limbo of sexual identity and emotional friction. Standing in this ecstatic and aesthetic demimonde awash with androgyny, pleasure, and wit is akin to stepping into the artist's mind. Thanks to the fin-de-siècle quality of the work, the environment evokes the following passage from Robert Musil's story "The Perfecting of a Love": "On this thin, scarcely real and yet so perceptible sensation the whole world hung as on a faintly trembling axis, and this in turn rested on the two people in the room. The objects all around held their breath, the light on the walls frozen into gold lace . . . everything was a silence and a waiting and was there because of them. Time, which runs through the world like an endless tinsel thread, seemed to pass through the center of this room and through the center of these people and suddenly to pause and petrify, stiff, still and glittering . . . and the objects in the room drew a little closer together."[2]

Gallagher and Cleijne's film installation *Murmur: Watery Ecstatic, Kabuki, Blizzard of White, Super Boo, Monster* (2003) is built on both of their respective bodies of work. Gallagher's paintings, drawings, and prints deconstruct the stereotypical representation of race as unfolded in vernacular culture. She has embraced a Trojan horse strategy and slipped herself in the canon of the avant-garde, meaning a post-Minimal understanding of repetition and seriality, or the praxis of "appropriation" and "detournement" in a post–Pop Art way. She muddied the water of such a diaphanous aesthetic by dropping in it the imprint of black faces and minstrelsy. In so doing, she manages an incongruous conversation between the opposite ends of the spectrum and formulates a counter-bamboozled disjunction in which beauty becomes a critical anomaly erected in the field of post–Civil Rights confusion and abnegation. Cleijne's photography and films take the form of a journey into the drastic shift of urban,

1. Edward W. Said, *Culture and Imperialism* (Vintage Books: New York, 1994), 19–31.

2. Robert Musil, "The Perfecting of a Love" in *Five Women* (Jaffrey, New Hampshire: David R. Godine, Publisher, Inc., 1999), 124.

demographic, and economic developments in West Africa. Through images, he narrates the individual disasters, understanding them for their etymological value: unfavorable to the stars, being born under the wrong one.

Murmur, their five 16mm film projections lodged in a mazelike architecture, bridges their respective concerns and, within a series of disruptive narratives, weaves the excruciating idea that the alienation and dislocation of the Middle Passage might just have mutated into more up-to-date, repressive entities. The installation is a body of signs that one can enter from diverse angles, which prevents the linearity of certainty and confuses, from one image to the other, what is fictional and what is reality-based. *Murmur* is an anachronistic essay on the legacy of images that encapsulate the conflicted history of forgetting.

For about 20 years, Hirschhorn has worked to reconsider the codes of sculpture through its forms, its materiality, and its role. Either in the street, in stores, or in the pristine space of galleries or institutions, he has elaborated a form in which he reactivates sculpture, and art in general, as an active critical laboratory. His aesthetic is one of precariousness of materials as well as of intent: the frailty of his adhesive tape, aluminum foil, cardboard, photocopied images, books, and ad hoc video matches the fragility of the philosophical, humanistic questions—the ones that so few dare ask in such a straightforward, brutal way. But fragility and frailty do not mean weakness or vulnerability. Frailty is his strength—a strategy to show his contempt for society's fascination with power as well as a way to question the gaps in knowledge structures. *Cavemanman* (2002) is not a sculpture, not an installation (though Hirschhorn does not subscribe to the latter denomination)—it is a project and an experience. It is a cave "architectured" with philosophical texts (including those of Aristotle, Benedict de Spinoza, Claude Lévi-Strauss, Noam Chomsky, and Alain Touraine), vernacular imagery, and humanistic statements (1 Man = 1 Man). *Cavemanman* is a universal monument to discontent, an anti-architecture of noncompliance populated by the doubts, the responses, the disbelief, and eventually the hostility of whoever inhabits it.

Cavemanman, *Murmur*, and *Solo für eine befallene Trompete* share the fact that they are human-induced microcosms that circumscribe an overwhelming relationship between the work and the spectator. The latter does not meander through the exhibition, but is immersed physically in a multidirectional, spatial experience that summons all the senses. In a way, spectatorship does not apply anymore; involvement is its substitute. The aesthetic motto of the exhibition is the impossibility of submissiveness and obedience.

Heart of Darkness—not truly a group exhibition, not exactly a solo project—is a space- and time-based experience, a sequence of correspondences. From one gallery to another, it invites a series of meditations oscillating between universal concerns and subjective and individual delineations. It suggests and conjures three ways to inhabit a social order: three representations remaining reticent to theory and favoring the sensible. Similarly, this publication is centered around the voices of the

artists[3] as well as those of two writers, Jacques Rancière and Jane Jacobs, who identify through their works and their words representative strategies linking history, politics, and psychology as a way to tell stories that do not ignore aesthetic investigation and pleasure.

Heart of Darkness is a cave, a world apart, where obsessions, apprehensions, fantasies, and passions are made amenable and available, not for the sake of dreamy escapism but as a means to ecstatically, aesthetically, intensely experiment and refine the art of being here and now.

3. Hirschhorn, Althoff, Gallagher, and Cleijne were interviewed for this book. Hirschhorn embraced a question-and-answer form via e-mail; Althoff responded to queries in a handwritten letter; and Gallagher and Cleijne's conversations with the author were adapted into a short essay.

THE HAZARD
Jane Jacobs

FROM: *DARK AGE AHEAD*

This is both a gloomy and a hopeful book.

The subject itself is gloomy. A Dark Age is a culture's dead end. We in North America and Western Europe, enjoying the many benefits of the culture conventionally known as the West, customarily think of a Dark Age as happening once, long ago, following the collapse of the Western Roman Empire. But in North America we live in a graveyard of lost aboriginal cultures, many of which were decisively finished off by mass amnesia in which even the memory of what was lost was also lost. Throughout the world Dark Ages have scrawled finis to successions of cultures receding far into the past. Whatever happened to the culture whose people produced the splendid Lascaux cave paintings some seventeen thousand years ago, in what is now southwestern France? Or the culture of the builders of ambitious stone and wood henges in Western Europe before the Celts arrived with their Iron Age technology and intricately knotted art?

Mass amnesia, striking as it is and seemingly weird, is the least mysterious of Dark Age phenomena. We all understand the harsh principle *Use it or lose it*. A failing or conquered culture can spiral down into a long decline, as has happened in most empires after their relatively short heydays of astonishing success. But in extreme cases, failing or conquered cultures can be genuinely lost, never to emerge again as living ways of being. The salient mystery of Dark Ages sets the stage for mass amnesia. People living in vigorous cultures typically treasure those cultures and resist any threat to them. How and why can a people so totally discard a formerly vital culture that it becomes literally lost?

This is a question that has practical importance for us here in North America, and possibly in Western Europe as well. Dark Ages are instructive, precisely because they are extreme examples of cultural collapse and thus more clear-cut and vivid than gradual decay. The purpose of this book is to help our culture avoid sliding into a dead end, by understanding how such a tragedy comes about, and thereby what can be done to ward it off and thus retain and further develop our living, functioning culture, which contains so much of value, so hard won by our forebears. We need this awareness because, as I plan to explain, we show signs of rushing headlong into a Dark Age.

Surely, the threat of losing all we have achieved, everything that makes us the vigorous society we are, cannot apply to us! How could it possibly happen to us? We have

books, magnificent storehouses of knowledge about our culture; we have pictures, both still and moving, and oceans of other cultural information that every day wash through the Internet, the daily press, scholarly journals, the careful catalogs of museum exhibitions, the reports compiled by government bureaucracies on every subject from judicial decisions to regulations for earthquake-resistant buildings, and, of course, time capsules.

Dark Ages, surely, are pre-printing and pre–World Wide Web phenomena. Even the Roman classical world was skimpily documented in comparison with our times. With all our information, how could our culture be lost? Or even almost lost? Don't we have it as well preserved as last season's peach crop, ready to nourish our descendants if need be?

Writing, printing, and the Internet give a false sense of security about the permanence of culture. Most of the million details of a complex, living culture are transmitted neither in writing nor pictorially. Instead, cultures live through word of mouth and example. That is why we have cooking classes and cooking demonstrations, as well as cookbooks. That is why we have apprenticeships, internships, student tours, and on-the-job training as well as manuals and textbooks. Every culture takes pains to educate its young so that they, in their turn, can practice and transmit it completely. Educators and mentors, whether they are parents, elders, or schoolmasters, use books and videos if they have them, but they also speak, and when they are more effective, as teachers, parents, or mentors, they also serve as examples.

As recipients of culture, as well as its producers, people attend to countless nuances that are assimilated only through experience. Men, women, and children in Holland conduct themselves differently from men, women, and children in England, even though both share the culture of the West, and very differently from their counterparts in Turkey, Saudi Arabia, or Singapore. Travel writers, novelists, visual artists, and photographers draw attention to subtle, everyday differences in conduct rooted in experience, including the experience of differing cultural histories, but their glosses are unavoidably sketchy, compared with the experience of living a culture, soaking it up by example and word of mouth.

Another thing: a living culture is forever changing, without losing itself as a framework and context of change. The reconstruction of a culture is not the same as its restoration. In the fifteenth century, scholars and antiquarians set about reconstructing the lost classical culture of Greece and Rome from that culture's writing and artifacts. Their work was useful and remains so to this day; Western Europeans relearned their cultural derivations from it. But Europeans also plunged, beginning in the fifteenth century, into the post-Renaissance crises of the Enlightenment. Profoundly disturbing new knowledge entered a fundamentalist and feudal framework so unprepared to receive it that some scientists were excommunicated and their findings rejected by an establishment that had managed to accept reconstructed classicism—and used it to refute newer knowledge. Copernicus' stunning proofs forced educated people to realize that the earth is not the center of the universe, as reconstructed classical

culture would have it. This and other discoveries, especially in the basic sciences of chemistry and physics, pitted the creative culture of the Enlightenment against the reconstructed culture of the Renaissance, which soon stood, ironically, as a barrier to cultural development of the West—a barrier formed by canned and preserved knowledge of kinds which we erroneously may imagine can save us from future decline or forgetfulness.

—

Dark Ages are horrible ordeals, incomparably worse than the temporary amnesia sometimes experienced by stunned survivors of earthquakes, battles, or bombing firestorms who abandon customary routines while they search for other survivors, grieve, and grapple with their own urgent needs, and who may forget the horrors they have witnessed, or try to. But later on, life for survivors continues for the most part as before, after having been suspended for the emergency.

During a Dark Age, the mass amnesia of survivors becomes permanent and profound. The previous way of life slides into an abyss of forgetfulness, almost as decisively as if it had not existed. Henri Pirenne, a great twentieth-century Belgian economic and social historian, says that the famous Dark Age which followed the collapse of the Western Roman Empire reached its nadir some six centuries later, about 1000 c.e. Here, sketched by two French historians, is the predicament of French peasantry in that year:

> The peasants . . . are half starved. The effects of chronic malnourishment are conspicuous in the skeletons exhumed. . . . The chafing of the teeth . . . indicates a grass-eating people, rickets, and an overwhelming preponderance of people who died young. . . . Even for the minority that survived infancy, the average life span did not exceed the age of forty. . . . Periodically the lack of food grows worse. For a year or two there will be a great famine; the chroniclers described the graphic and horrible episodes of this catastrophe, complacently and rather excessively conjuring up people who eat dirt and sell human skin. . . . There is little or no metal; iron is reserved for weapons.

So much had been forgotten in the forgetful centuries: the Romans' use of legumes in crop rotation to restore the soil; how to mine and smelt iron and make and transport picks for miners, and hammers and anvils for smiths; how to harvest honey from hollow-tile hives doubling as garden fences. In districts where even slaves had been well clothed, most people wore filthy rags.

Some three centuries after the Roman collapse, bubonic plague, hitherto unknown in Europe, crept in from North Africa, where it was endemic, and exploded into the first of many European bubonic plague epidemics. The Four Horsemen of the Apocalypse, conventionally depicted as Famine, War, Pestilence, and Death, had already been joined by a fifth demonic horseman, Forgetfulness.

A Dark Age is not merely a collection of subtractions. It is not a blank; much is added to fill the vacuum. But the additions break from the past and themselves reinforce a loss of the past. In Europe, languages that derived from formerly widely understood Latin diverged and became mutually incomprehensible. Everyday customs, rituals, and decorations diverged as old ones were lost; ethnic awarenesses came to the fore, often antagonistically; the embryos of nation-states were forming.

Citizenship gave way to serfdom; old Roman cities and towns were largely deserted and their underpopulated remnants sank into poverty and squalor; their former amenities, such as public baths and theatrical performances, became not even a memory. Gladiatorial battles and hungry wild animals unleashed upon prisoners were forgotten, too, but here and there, in backwaters, the memory of combat between and man on foot and a bull was retained because it was practiced. Diets changed, with gruel displacing bread, and salt fish and wild fowl almost displacing domesticated meat. Rules of inheritance and property holding changed. The composition of households changed drastically with conversion of Rome's traditional family-sized farms to feudal estates. Methods of warfare and ostensible reasons for warfare changed as the state and its laws gave way to exactions and oppressions by warlords.

Writers disappeared, along with readers and literacy, as schooling became rare. Religion changed as Christianity, formerly an obscure cult among hundreds of obscure cults, won enough adherents to become dominant and to be accepted as the state religion by Constantine, emperor of the still intact Eastern Roman Empire, and then, also as the state religion, in territorial remnants of the vanished Western Empire. The very definitions of virtue and the meaning of life changed. In Western Christendom, sexuality became highly suspect.

In sum, during the time of mass amnesia, not only was most classical culture forgotten, and what remained coarsened; but also, Western Europe underwent the most radical and thoroughgoing revolution in its recorded history—a political, economic, social, and ideological revolution that was unexamined and even largely unnoticed, as such, while it was under way. In the last desperate years before Western Rome's collapse, local governments had been expunged by imperial decree and were replaced by a centralized military despotism, not a workable organ for governmental judgments and reflections.

Similar phenomena are to be found in the obscure Dark Ages that bring defeated aboriginal cultures to a close. Many subtractions combine to erase a previous way of life, and everything changes as a richer past converts to a meager present and an alien future. During the conquest of North America by Europeans, an estimated twenty million aboriginals succumbed to imported diseases, warfare, and displacement from lands on which they and their hundreds of different cultures depended.

Their first response to the jolts of European invasion was to try to adapt familiar ways of life to the strange new circumstances. Some groups that had been accustomed to trading with one another, for example, forged seemingly workable trade

links with the invaders. But after more conquerors crowded in, remnants of aboriginal survivors were herded into isolated reservations. Adaptations of the old cultures became impossible and thus no longer relevant; so, piece by piece, the old cultures were shed. Some pieces were relinquished voluntarily in emulation of the conquerors, or surrendered for the sake of the invaders' alcohol, guns, and flour; most slipped away from disuse and forgetfulness.

As in Europe after Rome's collapse, everything changed for aboriginal survivors during the forgetful years: education of children; religions and rituals; the composition of households and societies; food; clothing; habitations; recreations; laws and recognized systems of ownership and land use; concepts of justice, dignity, shame, esteem. Languages changed, with many becoming extinct; crafts, skills—everything was gone. In sum, the lives of aboriginals had been revolutionized, mostly by outside forces but also, to a very minor extent, from within.

In the late twentieth century, as some survivors gradually became conscious of how much had been lost, they began behaving much like the scholarly pioneers of the fifteenth-century Italian Renaissance who searched for relics of classical Greek and Roman culture. Cree and Cherokee, Navajo and Haida groped for fragments of lost information by searching out old records and artifacts dispersed in their conquerors' museums and private collections. Jeered at by an uncomprehending white public of cultural winners, they began impolitely demanding the return of ancestral articles of clothing and decoration, of musical instruments, of masks, even of the bones of their dead, in attempts to retrieve what their peoples and cultures had been like before their lives were transformed by mass amnesia and unsought revolution.

When the abyss of lost memory by a people becomes too deep and too old, attempts to plumb it are futile. The Ainu, Caucasian aborigines of Japan, have a known modern history similar in some ways to that of North American aboriginals. Centuries before the European invasion of North America, the Ainu lost their foraging territories to invading ancestors of the modern Japanese. Surviving remnants of Ainu were settled in isolated reservations, most on Hokkaido, Japan's northern-most island, where they still live. The Ainu remain a mysterious people, to themselves as well as to others. Physical characteristics proclaim their European ancestry; they may be related to Norse peoples. But where in Europe they came from can only be conjectured. They retain no information about their locations or cultures there, nor by what route they reached Japan, nor why they traveled there. (See note, p. [28].)

—

Cultures that triumphed in unequal contests between conquering invaders and their victims have been meticulously analyzed by a brilliant twenty-first-century historian and scientist, Jared Diamond, who has explained his analyses in a splendidly accessible book, *Guns, Germs, and Steel*. He writes that he began his exploration with a question put to him by a youth in New Guinea, asking why Europeans and

Americans were successful and rich. The advantages that Diamond explored and the patterns he traces illuminate all instances of cultural wipeout.

Diamond argues persuasively that the difference between conquering and victim cultures is not owing to genetic discrepancies in intelligence or other inborn personal abilities among peoples, as racists persist in believing. He holds that, apart from variations in resistance to various diseases, the fates of cultures are not genetically influenced, let alone determined. But, he writes, successful invaders and conquerors have historically possessed certain crucial advantages conferred on them long ago by the luck of what he calls biogeography. The cultural ancestors of winners, he says, got head starts as outstandingly productive farmers and herders, producing ample and varied foods that could support large and dense populations.

Large and dense populations—in a word, cities—were able to support individuals and institutions engaged in activities other than direct food production. For example, such societies could support specialists in tool manufacturing, pottery making, boat-building, and barter, could organize and enforce legal codes, and could create priesthoods for celebrating and spreading religions, specialists for keeping accounts, and armed forces for defense and aggression.

Diamond's identification of basic causes of discrepancies in power among cultures boil down to good or bad geographical luck. His resulting causes boil down to size and density of populations and consequent differences in technological and organizational specialization. All these factors can be quantified.

This analysis worked so well for explaining the historical outcomes of conflicts that ranged over all the continents, and also on islands extending from the Arctic to the South Pacific, that Diamond hoped he had created the foundation for a genuine science of human history—a true, hard science, based on facts as solid and measurable as those underlying physics or chemistry, and as reliable for predicting future outcomes of conflict. It seemed to him that only a couple of loose ends needed tying.

One such was how cultures lost their memories. This was not hard for Diamond to explain as a consequence of *Use it or lose it*. He took as a vivid example the Tasmanians, who were nearly exterminated by invading Europeans in the nineteenth century. They were the most technologically primitive people to be recorded in modern history. They had no way to making fire, no boomerangs or spear throwers, no specialized stone tools, no canoes, no sewing needles, no ways of catching fish. Yet their parent culture, on the Australian mainland, had all these technologies. Presumably the Tasmanians did too, some ten thousand years previously, when they populated their island by traveling from the mainland over a prehistoric land bridge. Diamond remarks that a culture can lose a given technology for many reasons. Perhaps a certain raw material is in short supply; perhaps all the skilled artisans in a generation meet with tragedy. Whenever the Tasmanians lost an element of their culture, the loss would have been temporary had they still been in communication with the mainland, but because they were not, each loss became permanent.

The second loose end, however, threatened to unravel Diamond's whole fabric, as he recognized. According to his analyses, China and Mesopotamia, both of which had early and long leads over European cultures, should have securely maintained those leads, but did not. While neither experienced the extreme of a Dark Age, both succumbed to long declines, insidiously growing poverty, and backwardness relative to Europe. They inform us, as do the unedifying terminations of all great empires in the past, that strong and successful cultures can fail. The difference between these failures and those of conquered aboriginal cultures is that the death or the stagnated moribundity of formerly unassailable and vigorous cultures is caused not by assault from outside but by assault from within, that is, by internal rot in the form of fatal cultural turnings, not recognized as wrong turnings while they occur or soon enough afterward to be correctable. Time during which corrections can be made runs out because of mass forgetfulness.

Mesopotamia, the so-called Fertile Crescent of the Tigris and Euphrates rivers—traditionally thought to be the site of the biblical Garden of Eden—in historical times has centered on the fabled city of Baghdad. For some nine thousand years, starting in about 8500 B.C.E., almost every major innovation adopted in ancient Europe had originated in or very near the Fertile Crescent: grain cultivation; writing; brickmaking, masonry engineering, and construction; the wheel; weaving; pottery making; irrigation. Just as Diamond's attempted science of human history would predict, the Fertile Crescent was the seat of the ancient world's earliest empires: Sumer, Babylon, Assyria.

Yet with all its seemingly unbeatable advantages, something went so wrong in the Fertile Crescent that, as Diamond says, it is now absurd to couple "Fertile Crescent" with "world leader in food production. Today's ephemeral wealth[,] . . . based on the single non-renewable resource of oil, conceals the region's long-standing fundamental poverty and difficulty feeding itself."

Diamond asked himself how so gifted a region could lose its early, long lead over Europe. By 115 C.E., Mesopotamia had been conquered by Rome and became a Roman province. This was no temporary setback. Over the course of the next eighteen centuries, the region was passed around from invader to invader, eventually falling into the hands of the British Empire and Western oil corporations; a new chapter, of conflicts over oil, is not yet finished.

Diamond says the lead was lost through environmental ignorance. In ancient times, most of the Fertile Crescent and eastern Mediterranean was covered with forests. But to obtain more farmland and more timber, and to satisfy the plaster industry's relentless demands for wood fuel, the forest were cut faster than they could regenerate. Denuded valleys silted up, and intensified irrigation led to salt accumulations in the soil. Overgrazing by goats, allowing new growth no start in life, sealed the destruction. The damage had become irreversible, Diamond says, by 400 B.C.E. What escaped earlier has been done in recently: "The last forests . . . in modern Jordan . . . were felled by Ottoman Turks during railroad construction just before World War I." Most of the last wetlands, the great reed marshes of southern Iraq, with their com-

plex ecology of plants, mammals, insects, birds, and human beings, too—the "Marsh Arabs" who had occupied these lands for some five thousand years—fell to a drainage scheme undertaken for political reasons by Saddam Hussein in the 1990s, creating another barren, salt-encrusted desert.

Northern and Western Europe pulled abreast of Mesopotamia, then surpassed it, says Diamond, "not because [Europeans] have been wiser but because they had the good luck to live in a more robust environment with higher rainfall, in which vegetation grows quickly." Also, they herded cows and sheep, not goats.

The Fertile Crescent, along with the rest of the Middle East, reasserted its creative lead—not in food production but in science—during the triumphs of the Islamic empires. Islam was the most successful political, military, religious, and cultural entity of its time, asserting dominance from the eighth to the fifteenth centuries, westward through North Africa and Spain, eastward to South Asia. So far ahead of Europe was the scientific knowledge of Islam that most scientific and literary works from the classical period which Renaissance scholars finally obtained had been translated from Greek and Latin into Arabic; Islamic scholars later retranslated these texts into Latin for scholars in European Christendom. During this period, our ancestral European culture also obtained from Islam the nimble signs that we still call Arabic numerals, and that are indispensable to all our mathematics and all the achievements of measuring and reasoning that mathematics has made possible. Arabic numerals originated in the Fertile Crescent and India; the source of their most original and portentous addition, the zero, was the Fertile Crescent. The first known European mathematical use of the zero was in a Spanish manuscript dated 976 c.e. and believed to be derived from a Latin translation of a Baghdad work.

Although Diamond does not go into the second cultural deadening of the Fertile Crescent that brought to an end the second burst of world-altering scientific creativity there, another scholar, Karen Armstrong, has identified the point of no return as 1492, the year Ferdinand and Isabella drove the Muslims from Spain—their last important European foothold—in determination to expunge from their realm Muslims, Jews, Christian heretics, and other infidels. From then until the start of the nineteenth century, Mesopotamia deliberately attempted to shield itself from influences coming from the outside world.

Cultural xenophobia is a frequent sequel to a society's decline from cultural vigor. Someone has aptly called self-imposed isolation a fortress mentality. Armstrong describes it as a shift from faith in *logos*, reason, with its future-oriented spirit, "always . . . seeking to know more and to extend . . . areas of competence and control of the environment," to *mythos*, meaning conservatism that looks backward to fundamentalist beliefs for guidance and a worldview.

A fortress of fundamentalist mentality not only shuts itself off from dynamic influences originating outside but also, as a side effect, ceases influencing the outside world. Fortunately for our own culture, before Mesopotamia succeeded in entirely

sealing itself off, some of its talented and open-minded scientists fled to northern Italy, where they joined Galileo, Vesalius, and other precursors of the Enlightenment, who had their own hard battles to fight against spiritual and intellectual fundamentalism. Mesopotamian scientists helped make the University of Padua a preeminent world center of reason when our own ancestral culture needed rescue from the stultifying ideas that all valuable thought had already been thought and that disturbing new ideas—for example, that the earth is eons older than *mythos* admits—are unnecessary or dangerous.

China had much the same original advantages as the Fertile Crescent, plus greater rainfall, and retained its early lead longer. The large and dense population of medieval China enabled it to become the world leader in technology. Among its many innovations were cast iron, the compass, gunpowder, paper, printing with movable type, windmills, navigation equipment of all kinds, paper money, porcelain, and unparalleled silk spinning, weaving, and dyeing. China ruled the seas in the early fifteenth century. It sent vast numbers of cargo ships, called treasure fleets, across the Indian Ocean to the east coast of Africa, decades before Columbus crossed the Atlantic. The treasure fleets consisted of hundreds of ships, each as much as four hundred feet long. A fleet was manned by as many as twenty-eight thousand sailors. Centuries before the British Royal Navy learned to combat scurvy with rations of lime juice on long sea voyages, the Chinese had solved that problem by supplying ships with ordinary dried beans, which were moistened as need to make bean sprouts, a rich source of vitamin C.

Diamond asked himself why Chinese ships didn't colonize Europe before Vasco da Gama's three little Portuguese ships launched European's colonization of East Asia. "Why didn't Chinese ships . . . colonize America's west coast? Why did China lose its technological lead to formerly so backward Europe?"

In this case, the turning point was almost whimsical, like the plot of a musical or an operetta. In the early fifteenth century, a political power struggle was waged between two factions in the Chinese imperial bureaucracy. The losing faction had championed treasure fleets and taken an interest in their leadership and well-being. The winning faction asserted its success by abruptly calling a halt to voyages, forbidding further ocean voyaging, and dismantling shipyards.

In the complex Chinese culture, the loss of the great shipyards must have reverberated through the economy, affecting many other activities; so did the loss of the far-flung import and export trade. In 1433, with a capricious policy emerging from a tempest in a teapot, China's long stagnation began. A deeper cause than the court intrigue, Diamond points out, was that China was so tightly unified politically that "one decision stopped fleets over the whole of China." He contrasts this with Columbus' potential opportunities for sponsorship. After Columbus was turned down by the Duke of Anjou, and then in succession by the King of Portugal, the Duke of Medina-Sedona, and the Count of Meda-Celi, he finally hit the jackpot with Isabella and Ferdinand of Spain. Europe's political fragmentation and its therefore

decentralized decision making afforded crucial opportunities to Columbus and other explorers that were denied to mariners of the richer and more advanced Chinese. Unity, like many good things, is good only in moderation. The same can be said of disunity. In 1477, when a Chinese attempt was made to revive intercontinental ocean trading, the vice president of the War Ministry not only forbade it but destroyed all the documents regarding previous trading voyages. He called them "deceitful exaggerations of bizarre things, far removed from the testimony of people's eyes and ears," and said the ships had brought home nothing but "betel, bamboo staves, grape wine, pomegranates, ostrich eggs and such like odd things." Loss of charts and records from the archives ended medieval China's interest in the outside world, as well as the period of exploration.

China's wrong turning, capricious though it was, carried the double blow of surrender of its technological lead and simultaneous retreat into a fortress mentality. In China's case, the *mythos* for which *logos* was surrendered was Confucianism, an intellectual and social bequest from a sage of the long-distant past which was believed to contain all necessary precepts for the conduct of human beings in their relationships with one another and with their environment.

Diamond's analysis of winners and losers, elegantly precise and predictable wherever the forces at work were geography, climate, plants, animals, microorganisms, and demography, turned mushy and unreliable as soon as human decisions entered the equation. Yet, as he himself was the first to admit, a science of human history that omits the behavior of human beings is an absurdity. His brilliant analysis, as is, explains most outcomes of unequal contests between cultural winners and losers. But I think he limited its explanatory power unnecessarily by the way he posed his initial question: *What are the advantages that enable cultural conquerors to win conflicts with losers?*

Suppose we turn the question upside down and ask: *What dooms losers?* The answer to the new question, cast in the form of a principle, runs something like this: *Losers are confronted with such radical jolts in circumstances that their institutions cannot adapt adequately, become irrelevant, and are dropped.* This principle leaves scope for changes and jolts that arise within a culture, as well as changes and jolts imposed from outside.

A common example of a change imposed from the outside is the seizure by a conqueror of a hunting society's territory. As a consequence, both the practice and lore of successful hunting is lost from those cultures. The oldest resident of Fort Yukon, a man of about seventy in a predominantly American Indian community within the Arctic Circle, explained in 1994, "Our young fellows get me to tell them about the old hunting life. They think it would be so wonderful and exciting to follow it again instead of the dull jobs the school tries to prepare them for. But they don't realize how hard and chancy hunting was. They don't know enough to survive in the bush."

An example of a jolt from within is the overfishing of cod that has idled fishermen in Newfoundland villages. Some fishermen adapt by overfishing other groundfish and crabs, some by taking jobs in factories (almost always short-lived enterprises lured in and subsidized by the province); many, if they are young, emigrate to cities elsewhere in Canada; and others temporize and live on hopes that wealth from offshore oil drilling will trickle down to them in time. How to fish for cod is not forgotten yet, but it will be if the fish stocks don't recover soon, which they show no sign of doing after a decade-long moratorium.

Jolts from inside and outside are not basically different. What is lost from Diamond's erstwhile science of human history when we factor in human decisions is the aim he had of creating a genuinely hard science. Bringing in human decisions, as he did and as we must, changes the science itself, from a hard science to a soft one.

—

Some people think optimistically that if things get bad enough, they will get better because of the reaction of beneficent pendulums. When a culture is working wholesomely, beneficent pendulum swings—effective feedback—do occur. Corrective stabilization is one of the great services of democracy, with its feedback to rulers from the protesting and voting public. Stabilization is also one of the great services of some commercial innovations which, in concert with markets, shift production and consumption away from resources plagued by the high costs of diminishing returns, to substitutes or to other locales of production.

But powerful persons and groups that find it in their interest to prevent adaptive corrections have many ways of thwarting self-organizing stabilizers—through deliberately contrived subsidies and monopolies, for example. Or circumstances may have allowed cultural destruction to drift to a point where the jolts of correction appear more menacing than downward drift. Gibbon's *Decline and Fall of the Roman Empire* is stuffed with instances of drift that became monstrous and ultimately proved impossible to correct. For instance, as shortfalls in the Roman treasury—which had their own economic causes—made it impossible to pay Rome's legions adequately and on time, elite guard units took into their own hands the power of choosing emperors in hopes of ensuring their own well-being. This made a shambles of orderly government successions and policies, including budgets for support the legions—a shambles that with time grew worse, not better. In the half century from 235 C.E. to 284 C.E., Rome had twenty-six army-acclaimed emperors, who, with only one exception, succumbed to public assassinations or private murders. Rome's other major institutions, such as the Senate and the empire's diplomatic structures, were implicated in this bizarre sequence, either through their own corruption or by pernicious drifts of their own.

The human causes of Rome's collapse have been studied minutely, and one thing that can be learned is that everything is connected with everything else, not only in its consequences but also in its causes. We may be sure that the story of the desertification

of the Fertile Crescent, cited by Diamond, was not simple. At the least, corrective adaptation that would have threatened the plaster industry (which was so voraciously consuming forests for fuel) and would have handicapped goatherding and its dependent industries must have appeared, at the time, to be less feasible than continuing to ruin the land itself.

In the case of China's self-imposed stagnation as a by-product of political squabbling, we must bring in the usual complicating fact that everything was connected to everything else, and add the reality I mentioned earlier: that even in a literate and archive-keeping society, which medieval China was, time for corrective action is finite: culture resides mainly in people's heads and in the examples people set, and is subject therefore to natural mortality. Thousands of details of shipbuilding, equipping, navigating, and trading practices obviously went into the complicated creation, finance, and operation of treasure fleets. As the people who had competently maintained this organizational wonder died off, so must have cultural competence to follow in their footsteps.

People get used to losses (fortunately, or life would be unbearable) and take absences for granted. So it must have been, eventually, with Chinese ocean voyages. In North America, a couple of decades ago, it was common to hear residents remark, as they locked up for a short departure from home, that they never used to need to lock their doors. Nowadays, the remark is seldom heard. People who once didn't need to lock their doors have gradually died off, and so even the memory of what has been lost is now almost lost. As for reconstituting that particular security, what with everything connecting to everything else—the illegal drug trade, police corruption, racism, poverty, and inadequate education—theft and robbery are so intractably complex as to defy solution. The only reason I know that unlocked-door security is actually possible (although my mother used to frequently comment about formerly not having to lock the door) is that I have experienced unlocked security, with amazement, during a visit to Tokyo, Kyoto, and Osaka in 1972.

The collapse of one sustaining cultural institution enfeebles others, making it more likely that others will give way. With each collapse, still further ruin becomes more likely, until finally the whole enfeebled, intractable contraption crashes. Beneficent corrections of deterioration are not guaranteed.

—

A cultural is unsalvageable if stabilizing forces themselves become ruined and irrelevant. This is what I fear for our own culture, and why I have written this cautionary book in hopeful expectation that time remains for corrective actions. Each correction benefits others, making connections within the culture beneficial instead of malignant.

In the five chapters that follow, I single out five pillars of our culture that we depend on to stand firm, and discuss what seem to me ominous signs of their decay. They

are in process of becoming irrelevant, and so are dangerously close to the brink of lost memory and cultural uselessness. These five jeopardized pillars are

- community and family (the two are so tightly connected they cannot be considered separately)
- higher education
- the effective practice of science and science-based technology (again, so tightly connected they cannot be considered separately)
- taxes and governmental powers directly in touch with needs and possibilities
- self-policing by the learned professions.

It may seem surprising that I do not single out such failings as racism, profligate environmental destruction, crime, voters' distrust of politicians and thus low turn-outs for elections, and the enlarging gulf between rich and poor along with attrition of the middle class. Why not those five, rather than the five I have selected to concentrate upon? Surely the second five indicate serious cultural dysfunction. Perhaps my judgment is wrong, but I think these second five are symptoms of breakdown in the five I have chosen to discuss. Furthermore, many North Americans are already aware of them as dangerous flaws and are trying to focus on intelligent corrections.

The weaknesses I single out in the five pillars are less recognized, I think. These pillars are crucial to the culture and are insidiously decaying. Other institutions may be as deserving of alarmed attention. Hindsight may well expose my blind spots. Indeed, it surely will if we continue drifting, heedless of our culture's well-being. I can only apologize for being less omniscient than I should be as I take up a responsibility—which I hope readers will also assume—for trying to do the small bit I can to give stabilizing corrections a push. A culture is a vast and obdurate entity, difficult to divert from a mistaken course upon which it has set. Following my discussion of the decay of the five cultural pillars, I attempt practical suggestions for reversing some intractable deteriorations.

My last chapter returns to patterns of Dark Ages and less extreme deteriorations, and puts them into larger context than our own vexations. It also suggests why our predicament—the shift to postagrarianism—is so jolting that if our culture and our contemporaries' pull through more or less intact, we will all deserve posterity's gratitude.

Although the chapters that follow are structured as a collection of warnings, this book should not be mistaken for prophecy. Life is full of surprises—some of them good, with large, beneficial, totally unforeseen consequences. Prophecy is for people too ignorant of history to be aware of that, or for charlatans. However, by definition, we can't rely on surprise rescues; mostly we must lie in the beds we make on the mattresses our culture provides.

One aspect of luck is that companion cultures can be rescued by one another, in part by welcoming exiles and their ways. This has often happened. I have already given some examples of the remarkable aid given our ancestral culture centuries ago by the culture of Mesopotamia, of all places, when it was already deeply in trouble itself.

In the following six chapters I have confined my analysis to North America because that is the culture I know best. However, its direct ancestral culture is that of Western Europe, which has many branches other than the North American offshoot. Among the disturbing phenomena I observe is that the same ills besetting the United States and Canada menace other branches of the West, if not yet as acutely. Maybe the most useful service of the cautions that follow is to alert societies that suppose they have an exemplary model in America; they would do well to pause, be wary, and sift carefully, discriminating between much that is constructive and vigorous, or at worst merely novel and harmless, and much that is destructive and deadening.

NOTES AND COMMENTS

1. The Hazard

Stewart Brand, in *The Clock of the Long Now* (New York: Basic Books, 1999), points out the fragility of preserved knowledge, including that on computer disks and tapes, which are increasingly relied on to preserve newspapers, letters, books, and microfilm. Seeking a strategy to preserve information for thousands of years, he argues that this can only be done by teaching information curators to renew the physical carriers of information before their extinction is threatened; in other words, it has to be done by generations of human beings culturally instructed to fulfill this purpose.

—

Henri Pirenne (1862–1935), with his pathbreaking books on the early economic, political, and social development of the cities of medieval western Europe, laid the foundations for modern understanding of cities. He recognized cities as the engines of economic life and explained why they are. In his *Medieval Cities* (Princeton: Princeton University Press, 1925; paperback edition, New York: Doubleday/Anchor, 1956), he correlates the deepening poverty of Europe through the tenth century with atrophy of city trade in the Mediterranean world (owing to Christian prohibitions against trading with infidels), and the revival of western and northern Europe with revival of intercity trade and, indirectly through Venice, trade with the more advanced Middle East and Asia.

An obtuse foreword by Lewis Mumford to a Princeton paperback edition criticizes Pirenne for his emphasis on cities as economic entities. This is of historical interest in showing how far in advance of the conventional thinking of his day Pirenne's work was, and indeed how far in advance it still is from popular and political—and much academic—understanding of cities, trade, and economic development. Foreign-aid donors and recipients of our time would do well to take to heart Pirenne's lessons on the processes of economic revival and development. His is a basic text for understanding how the world's economic networks operate and how they fail.

—

The *History of French Civilization* by Georges Duby and Robert
Mandrou (Paris; Max Leclerc, 1958; English edition, translated by
James Blakely Atkinson, New York: Random House, 1964) takes
as its point of departure the nadir in Europe's postclassical for-
tunes. The quotation citing the misery of early-eleventh-century
peasantry (a category that included most Europeans of the time)
is taken from p. 7. The first 110 pages explain lucidly how the mun-
dane effects of the slow economic revival shaped feudal France
and its institutions, and then also began shaping the Old Regime,
which was terminated some eight centuries later by the French
Revolution. In those pages an alert reader can also find very early
intimations of French cultural characteristics that are significant
to this day. The remainder of the book is worth pondering, too,
especially by those interested in French literature and art and the
formation of culture generally.

—

The estimate of twenty million deaths of North American aborigi-
nals as a consequence of European invasion and conquests is
taken from Jared Diamond's *Guns, Germs, and Steel: The Fates
of Human Societies* (New York: Norton, 1997; paperback, 1999).
Diamond estimates that 90 percent of the deaths were from
imported diseases, especially smallpox. Measles and whooping
cough, which were relatively innocuous to children of European
descent, wreaked havoc among aboriginal children well into the
twentieth century. Diamond is fascinating on differential group
resistances to two great classes of infectious diseases: (a) those
endemic in nomadic and other scanty human populations; and
(b) those epidemic in dense populations.

—

I have learned yet again (this has been going on all my life) what
folly it is to take anything for granted without examining it skepti-
cally. When I wrote on p. [18] about the Ainu, I shared the assump-
tion of physical anthropologists that because Ainu have light skins
and European facial and skull features and patterns of body hair,
they were migrants to Japan from Europe. A mistake. There must
obviously have been a time when anatomically modern human
beings were generalized—that is, still too new a species to have
distinctive family resemblances associated with specific places.
The Ainu represent "preracial" human beings. So we are told by
Steve Olson, author of *Mapping Human History: Discovering the
Past Through Our Genes* (Boston: Houghton Mifflin, 2002).

The *original* aboriginals of Japan are known to paleoanthropolo-
gists as Jomonese. They reached what is now Japan more than
ten thousand years ago, lacked "Oriental" facial features and body
types, and were apparently the first people to invent pottery. Olson
says their fossils indicate that they "represented an early migra-
tion of people" north from Australia and southeastern Asia, en
route from East Africa. The Jomonese live on in modern Japanese
people, contributing a major component to the Japanese gene

pool. They also appear to have been ancestors of the Ainu. The other major contributors to Japanese heredity were the Yayoi, rice farmers, metalworkers, and weavers who invaded about 300 B.C.E. from China or Korea, having developed what we now think of as Asian features in the meantime. The Yayoi pushed the Ainu north.

—

Wilfred Theisger, the author of *The Marsh Arabs* (New York: Penguin Books, 1967), lived as a doctor among these people for eight years. His marvelous description of their extraordinary way of life and their unique part of the world was reissued in 1985 by HarperCollins, in hardcover, with beautiful color photographs.

Photographs by Nik Wheeler taken in 1974 were published in the *New York Times*, January 26, 2003. The *Times* reported that in 1992, the fabulous reed beds were burned, the lagoons were poisoned, and fugitive human beings were rounded up and executed. This was a sequel to a Shiite Muslim rebellion against Saddam Hussein at the end of the First Gulf War. The marshes have not become a battleground (so far) after the Second Gulf War, but by that point the Marsh Arabs had "virtually ceased to exist," the *Times* reported. The northern approach to the southern city of Basra, where British troops battled to secure the city, is a site—now desert—of some of the former wetlands.

Karen Armstrong's *Islam: A Short History* (New York: Modern Library, 2000) combines religious, military, political, economic, and social history with analysis.

—

The remark by the fifteenth-century Chinese war official about the worthlessness of China's ocean trading appears in Anthony Pagden's *Peoples and Empires: A Short History of European Migration, Exploration, and Conquest, from Greece to the Present* (New York: Modern Library, 2001). Pagden says that "no one really knows" why the Chinese halted ocean voyaging. Important consequences do not necessarily have important causes or widely known motives—especially when decisions are made by small elites who choose to be secretive.

—

The old Fort Yukon trapper's remarks were an oral communication, which I have quoted from memory.

—

For a discussion of the part played by feedback in correcting instability and restoring operating equilibrium, see Chapter 5, "Evading Collapse," in my book *The Nature of Economies* (New York and Toronto: Modern Library and Random House of Canada, 2000; paperback editions, Toronto and New York: Vintage Canada and Vintage, 2001).

—

The bizarre half century of rapidly acclaimed and murdered Roman emperors was brought to an end by Diocletian, a tough old soldier of peasant stock from what is now the Dalmatian coast of Croatia. He held on to his exalted job, and his life, by promising in advance of his acclamation that he would abdicate voluntarily after twenty years. He kept his promise, but was unable to use the time to stem Rome's economic and military chaos. Indeed, his extravagant and radical reorganizations and reforms, although well-meant, probably hastened the terminal collapse.

Rome never did clarify for itself how an emperor should be chosen or removed. It was scornful of kings and dynasties, having disposed of royal Etruscan rule early in its history when it was a small, weak city-state. Its emperors, starting with Augustus, clung to fictional republican titles, while also being worshipped as gods. Moses Hadas, a modern American historian of the classical and ancient world, commented dryly that "the anomaly of an autocrat who pretended to be a republican magistrate entailed serious awkwardnesses in determining the succession." Hadas, *A History of Rome from Its Origins to 529 A.D. as Told by the Roman Historians* (New York: Doubleday/Anchor, 1956).

—

The unlocked security I observed in Japan in 1972 included shops— often with valuable contents—left unlocked while proprietors were absent for lunch or whatever, leaving customers free to browse without attendants; luggage left unattended while owners wandered away; and many valuable items such as cameras, radios, and shopping bags filled with newly purchased clothing left unwatched, along with shoes, outside temples and shrines. I suspect that last custom may have been the genesis of this pervasive sense of security against theft.

Writer and activist Jane Jacobs (1916–2006) is the author of *The Death and Life of Great American Cities* (1961), a work that has never gone out of print and has transformed the disciplines of urban planning and city architecture. Throughout her career, she produced a series of analytical and visionary essays and books that examine the development of complex human systems and environments in such fields as urban design, urban history, regional economics, the morality of the economy, and the nature of economic growth. Her other major books include: *The Economy of Cities* (1969); *Cities and the Wealth of Nations: Principles of Economic Life* (1984); *Systems of Survival: A Dialogue on the Moral Foundations of Commerce and Politics* (1992); *The Nature of Economies* (2000); and *Dark Age Ahead* (2004). A Canadian citizen since 1973, Jacobs moved in 1968 from New York to Toronto, where she lived until her death in April 2006 at age 89.

THE AESTHETIC REVOLUTION AND ITS OUTCOMES:
EMPLOTMENTS OF AUTONOMY AND HETERONOMY
Jacques Rancière

FROM: *NEW LEFT REVIEW* 14
March–April 2002

At the end of the fifteenth of his *Letters on the Aesthetic Education of Mankind* Schiller states a paradox and makes a promise. He declares that "Man is only completely human when he plays," and assures us that this paradox is capable "of bearing the whole edifice of the art of the beautiful and of the still more difficult art of living." We could reformulate this thought as follows: there exists a specific sensory experience—the aesthetic—that holds the promise of both a new world of Art and a new life for individuals and the community. There are different ways of coming to terms with this statement and this promise. You can say that they virtually define the "aesthetic illusion" as a device which merely serves to mask the reality that aesthetic judgment is structured by class domination. In my view that is not the most productive approach. You can say, conversely, that the statement and the promise were only too true, and that we have experienced the reality of that "art of living" and of that "play," as much in totalitarian attempts at making the community into a work of art as in the everyday aestheticized life of a liberal society and its commercial entertainment. Caricatural as it may appear, I believe this attitude is more pertinent. The point is that neither the statement nor the promise were ineffectual. At stake here is not the "influence" of a thinker, but the efficacy of a plot—one that reframes the division of the forms of our experience.

This plot has taken shape in theoretical discourses and in practical attitudes, in modes of individual perception and in social institutions—museums, libraries, educational programs; and in commercial inventions as well. My aim is to try to understand the principle of its efficacy, and of its various and antithetical mutations. How can the notions of "aesthetics" as a specific experience lead at once to the idea of a pure world of art and of the self-suppression of art in life, to the tradition of avant-garde radicalism and to the aestheticization of common existence? In a sense, the whole problem lies in a very small preposition. Schiller says that aesthetic experience will bear the edifice of the art of the beautiful *and* of the art of living. The entire question of the "politics of aesthetics"—in other words, of the aesthetic regime of art—turns on this short conjunction. The aesthetic experience is effective inasmuch as it is the experience of that *and*. It grounds the autonomy of art, to the extent that it connects it to the hope of "changing life." Matters would be easy if we could merely say—naïvely—that the beauties of art must be subtracted from any politicization, or—knowingly—that the alleged autonomy of art disguises its dependence upon domination. Unfortunately this is not the case: Schiller says that the "play drive"—*Spieltrieb*—will reconstruct both the edifice of art and the edifice of life.

Militant workers of the 1840s break out of the circle of domination by reading and writing not popular and militant, but "high" literature. The bourgeois critics of the 1860s denounce Flaubert's posture of "art for art's sake" as the embodiment of democracy. Mallarmé wants to separate the "essential language" of poetry from common speech, yet claims that it is poetry which gives the community the "seal" it lacks. Rodchenko takes his photographs of Soviet workers or gymnasts from an overhead angle which squashes their bodies and movements, to construct the surface of an egalitarian equivalence of art and life. Adorno says that art must be entirely self-contained, the better to make the blotch of the unconscious appear and denounce the lie of autonomized art. Lyotard contends that the task of the avant-garde is to isolate art from cultural demand so that it may testify all the more starkly to the heteronomy of thought. We could extend the list *ad infinitum*. All these positions reveal the same basic emplotment of an *and*, the same knot binding together autonomy and heteronomy.

Understanding the "politics" proper to the aesthetic regime of art means understanding the way autonomy and heteronomy are originally linked in Schiller's formula.[1] This may be summed up in three points. Firstly, the autonomy staged by the aesthetic regime of art is not that of the work of art, but of a mode of experience. Secondly, the "aesthetic experience" is one of heterogeneity, such that for the subject of that experience it is also the dismissal of a certain autonomy. Thirdly, the object of that experience is "aesthetic," in so far as it is not—or at least not only—art. Such is the threefold relation that Schiller sets up in what we can call the "original scene" of aesthetics.

SENSORIUM OF THE GODDESS

At the end of the fifteenth letter, he places himself and his readers in front of a specimen of "free appearance," a Greek statue known as the Juno Ludovisi. The statue is "self-contained," and "dwells in itself," as befits the traits of the divinity: her "idleness," her distance from any care or duty, from any purpose or volition. The goddess is such because she wears no trace of will or aim. Obviously, the qualities of the

1. I distinguish between three regimes of art. In the ethical regime, works of art have no autonomy. They are viewed as images to be questioned for their truth and for their effect on the ethos of individuals and the community. Plato's *Republic* offers a perfect model of this regime. In the representational regime, works of art belong to the sphere of imitation, and so are no longer subject to the laws of truth or the common rules of utility. They are not so much copies of reality as ways of imposing a form on matter. As such, they are subject to a set of intrinsic norms: a hierarchy of genres, adequation of expression to subject matter, correspondence between the arts, etc. The aesthetic regime overthrows this normativity and the relationship between form and matter on which it is based. Works of art are now defined as such, by belonging to a specific sensorium that stands out as an exception from the normal regime of the sensible, which presents us with an immediate adequation of thought and sensible materiality. For further detail, see Jacques Rancière, *Le Partage du sensible: Esthétique et Politique* (Paris: La Fabrique, 2000).

goddess are those of the statue as well. The statue thus comes paradoxically to fig-
ure what has not been made, what was never an object of will. In other words: it
embodies the qualities of what is not a work of art. (We should note in passing that
formulas of the type "this is" or "this is not" a work of art, "this is" or "this is not a
pipe," have to be traced back to this originary scene, if we want to make of them
more than hackneyed jokes.)

Correspondingly, the spectator who experiences the free play of the aesthetic in
front of the "free appearance" enjoys an autonomy of a very special kind. It is not
the autonomy of free Reason, subduing the anarchy of sensation. It is the suspen-
sion of that kind of autonomy. It is an autonomy strictly related to a withdrawal
of power. The "free appearance" stands in front of us, unapproachable, unavailable
to our knowledge, our aims and desires. The subject is promised the possession of
a new world by this figure that he cannot possess in any way. The goddess and the
spectator, the free play and the free appearance, are caught up together in a specific
sensorium, cancelling the oppositions of activity and passivity, will and resistance.
The "autonomy of art" and the "promise of politics" are not counterposed. The
autonomy is the autonomy of the experience, not of the work of art. To put it differ-
ently, the artwork participates in the sensorium of autonomy inasmuch as it is not
a work of art.

Now this "not being a work of art" immediately takes on a new meaning. The free
appearance of the statue is the appearance of what has not been aimed at as art.
This means that it is the appearance of a form of life in which art is not art. The "self-
containment" of the Greek statue turns out to be the "self-sufficiency" of a collective
life that does not rend itself into separate spheres of activities, of a community where
art and life, art and politics, life and politics are not severed one from another. Such
is supposed to have been the Greek people whose autonomy of life is expressed in
the self-containment of the statue. The accuracy or otherwise of that vision of ancient
Greece is not at issue here. What is at stake is the shift in the idea of autonomy, as
it is linked to that of heteronomy. At first autonomy was tied to the "unavailability"
of the object of aesthetic experience. Then it turns out to be the autonomy of a life
in which art has no separate existence—in which its productions are in fact self-
expressions of life. "Free appearance," as the encounter of a heterogeneity, is no
more. It ceases to be a suspension of the oppositions of form and matter, of activity
and passivity, and becomes the product of a human mind which seeks to transform
the surface of sensory appearances into a new sensorium that is the mirror of its
own activity. The last letters of Schiller unfold this plot, as primitive man gradually
learns to cast an aesthetic gaze on his arms and tools or on his own body, to sepa-
rate the pleasure of appearance from the functionality of objects. Aesthetic play
thus becomes a work of aestheticization. The plot of a "free play," suspending the
power of active form over passive matter and promising a still unheard-of state of
equality, becomes another plot, in which form subjugates matter, and the self-educa-
tion of mankind is its emancipation from materiality, as it transforms the world into
its own sensorium.

So the original scene of aesthetics reveals a contradiction that is not the opposition of art versus politics, high art versus popular culture, or art versus the aestheticization of life. All these oppositions are particular features and interpretations of a more basic contradiction. In the aesthetic regime of art, art is art to the extent that it is something else than art. It is always "aestheticized," meaning that it is always posed as a "form of life." The key formula of the aesthetic regime of art is that art is an autonomous form of life. This is a formula, however, that can be read in two different ways: autonomy can be stressed over life, or life over autonomy—and these lines of interpretation can be opposed, or they can intersect.

Such oppositions and intersections can be traced as the interplay between three major scenarios. Art can become life. Life can become art. Art and life can exchange their properties. These three scenarios yield three configurations of the aesthetic, emplotted in three versions of temporality. According to the logic of the *and*, each is also a variant of the politics of aesthetics, or what we should rather call its "meta-politics"—that is, its way of producing its own politics, proposing to politics rearrangements of its space, reconfiguring art as a political issue, or asserting itself as true politics.

CONSTITUTING THE NEW COLLECTIVE WORLD

The first scenario is that of "art becoming life." In this schema art is taken to be not only an expression of life but a form of its self-education. What this means is that, beyond its destruction of the representational regime, the aesthetic regime of art comes to terms with the ethical regime of images in a two-pronged relationship. It rejects its partitioning of times and spaces, sites and functions. But it ratifies its basic principle: matters of art are matters of education. As self-education art is the formation of a new sensorium—one which signifies, in actuality, a new ethos. Taken to an extreme, this means that the "aesthetic self-education of humanity" will frame a new collective ethos. The politics of aesthetics proves to be the right way to achieve what was pursued in vain by the aesthetics of politics, with its polemical configuration of the common world. Aesthetics promised a non-polemical, consensual framing of the common world. Ultimately the alternative to politics turns out to be aestheticization, viewed as the constitution of a new collective ethos. This scenario was first set out in the little draft associated with Hegel, Hölderlin, and Schelling, known as the "Oldest System-Programme of German Idealism." The scenario makes politics vanish in the sheer opposition between the dead mechanism of the State and the living power of the community, framed by the power of living thought. The vocation of poetry—the task of "aesthetic education"—is to render ideas sensible by turning them into living images, creating an equivalent of ancient mythology, as the fabric of a common experience shared by the elite and by the common people. In their words: "mythology must become philosophy to make common people reasonable and philosophy must become mythology to make philosophers sensible."

This draft would not be just a forgotten dream of the 1790s. It laid the basis for a new idea of revolution. Even though Marx never read the draft, we can discern the same plot in his well-known texts of the 1840s. The coming Revolution will be at once the consummation and abolition of philosophy; no longer merely "formal" and "political," it will be a "human" revolution. The human revolution is an offspring of the aesthetic paradigm. That is why there could be a juncture between the Marxist vanguard and the artistic avant-garde in the 1920s, as each side was attached to the same programme: the construction of new forms of life, in which the self-suppression of politics would match the self-suppression of art. Pushed to this extreme the originary logic of the "aesthetic state" is reversed. Free appearance was an appearance that did not refer to any "truth" lying behind or beneath it. But when it becomes the expression of a certain life, it refers again to a truth to which it bears witness. In the next step, this embodied truth is opposed to the lie of appearances. When the aesthetic revolution assumes the shape of a "human" revolution cancelling the "formal" one, the originary logic has been overturned. The autonomy of the idle divinity, its unavailability had once promised a new age of equality. Now the fulfilment of that promise is identified with the act of a subject who does away with all such appearances, which were only the dream of something he must now possess as reality.

But we should not for all that simply equate the scenario of art becoming life with the disasters of the "aesthetic absolute," embodied in the totalitarian figure of the collectivity as a work of art. The same scenario can be traced in more sober attempts to make art the form of life. We may think, for instance, of the way the theory and practice of the Arts and Crafts movement tied a sense of eternal beauty, and a mediaeval dream of handicrafts and artisan guilds, to concern with the exploitation of the working class and the tenor of everyday life, and to issues of functionality. William Morris was among the first to claim that an armchair is beautiful if it provides a restful seat, rather than satisfying the pictorial fantasies of its owner. Or let us take Mallarmé, a poet often viewed as the incarnation of artistic purism. Those who cherish his phrase "this mad gesture of writing" as a formula for the "intransitivity" of the text often forget the end of his sentence, which assigns the poet the task of "re-creating everything, out of reminiscences, to show that we actually are at the place we have to be." The allegedly "pure" practice of writing is linked to the need to create forms that participate in a general reframing of the human abode, so that the productions of the poet are, in the same breath, compared both to ceremonies of collective life, like the fireworks of Bastille Day, and to private ornaments of the household.

It is no coincidence that in Kant's Critique of Judgement significant examples of aesthetic apprehension were taken from painted décors that were "free beauty" in so far as they represented no subject, but simply contributed to the enjoyment of a place of sociability. We know how far the transformations of art and its visibility were linked to controversies over the ornament. Polemical programmes to reduce all ornamentation to function, in the style of Loos, or to extol its autonomous signifying power, in the manner of Riegl or Worringer, appealed to the same basic principle: art is first of all a matter of dwelling in a common world. That is why the same discussions about

the ornament could support ideas both of abstract painting and of industrial design. The notion of "art becoming life" does not simply foster demiurgic projects of a "new life." It also weaves a common temporality of art, which can be summed up in a simple formula: a new life needs a new art. "Pure" art and "committed" art, "fine" art and "applied" art, alike partake of this temporality. Of course, they understand and fulfil it in very different ways. In 1897, when Mallarmé wrote his *Un coup de dés*, he wanted the arrangement of lines and size of characters on the page to match the form of his idea—the fall of the dice. Some years later Peter Behrens designed the lamps and kettles, trademark, and catalogues of the German General Electricity Company. What have they in common?

The answer, I believe, is a certain conception of design. The poet wants to replace the representational subject-matter of poetry with the design of a general form, to make the poem like a choreography or the unfolding of a fan. He calls these general forms "types." The engineer-designer wants to create objects whose form fits their use and advertisements which offer exact information about them, without commercial embellishment. He also calls these forms "types." He thinks of himself as an artist, inasmuch as he attempts to create a culture of everyday life that is in keeping with the progress of industrial production and artistic design, rather than with the routines of commerce and petty-bourgeois consumption. His types are symbols of common life. But so are Mallarmé's. They are part of the project of building, above the level of the monetary economy, a symbolic economy that would display a collective "justice" or "magnificence," a celebration of the human abode replacing the forlorn ceremonies of throne and religion. Far from each other as the symbolist poet and the functionalist engineer may seem, they share the idea that forms of art should be modes of collective education. Both industrial production and artistic creation are committed to doing something else than what they do—to create not only objects but a sensorium, a new partition of the perceptible.

FRAMING THE LIFE OF ART

Such is the first scenario. The second is the schema of "life becoming art" or the "life of art." This scenario may be given the title of a book by the French art historian Élie Faure, *The Spirit of Forms*: the life of art as the development of a series of forms in which life becomes art. This is in fact the plot of the Museum, conceived not as a building and an institution but as a mode of rendering visible and intelligible the "life of art." We know that the birth of such museums around 1800 unleashed bitter disputes. Their opponents argued that the works of art should not be torn away from their setting, the physical and spiritual soil that gave birth to them. Now and then this polemic is renewed today: the museum denounced as a mausoleum dedicated to the contemplation of dead icons, separated from the life of art. Others hold that, on the contrary, museums have to be blank surfaces so that spectators can be confronted with the artwork itself, undistracted by the ongoing culturalization and historicization of art.

Both, in my view, are mistaken. There is not opposition between life and mausoleum, blank surface and historicized artefact. From the beginning the scenario of the art museum has been that of an aesthetic condition in which the Juno Ludovisi is not so much the work of a master sculptor as a "living form," expressive both of the independence of "free appearance" and of the vital spirit of a community. Our museums of fine arts don't display pure specimens of fine art. They display historicized art: Fra Angelico between Giotto and Masaccio, framing an idea of Florentine princely splendour and religious fervour; Rembrandt between Hals and Vermeer, featuring Dutch domestic and civic life, the rise of the bourgeoisie, and so on. They exhibit a time-space of art as so many moments of the incarnation of thought.

To frame this plot was the first task of the discourse named "aesthetics," and we know how Hegel, after Schelling, completed it. The principle of the framing is clear: the properties of the aesthetic experience are transferred to the work of art itself, cancelling their projection into a new life and invalidating the aesthetic revolution. The "spirit of forms" becomes the inverted image of the aesthetic revolution. This reworking involves two main moves. First, the equivalence of activity and passivity, form and matter, that characterized the "aesthetic experience" turns out to be the status of the artwork itself, now posited as an identity of consciousness and unconsciousness, will and un-will. Second, this identity of contraries at the same stroke lends works of art their historicity. The "political" character of aesthetic experience is, as it were, reversed and encapsulated in the historicity of the statue. The statue is a living form. But the meaning of the link between art and life has shifted. The statue, in Hegel's view, is art not so much because it is the expression of a collective freedom, but rather because it figures the distance between that collective life and the way it can express itself. The Greek statue, according to him, is the work of an artist expressing an idea of which he is aware and unaware at the same time. He wants to embody the idea of divinity in a figure of stone. But what he can express is only the idea of the divinity that he can feel and that the stone can express. The autonomous form of the statue embodies divinity as the Greeks could at best conceive of it—that is, deprived of interiority. It does not matter whether we subscribe to this judgment or not. What matters is that, in this scenario, the limit of the artist, of his idea and of his people, is also the condition for the success of the work of art. Art is living so long as it expresses a thought unclear to itself in a matter that resists it. It lives inasmuch as it is something else than art, that is a belief and a way of life.

This plot of the spirit of forms results in an ambiguous historicity of art. On the one hand, it creates an autonomous life of art as an expression of history, open to new kinds of development. When Kandinsky claims for a new abstract expression an inner necessity, which revives the impulses and forms of primitive art, he holds fast to the spirit of forms and opposes its legacy to academicism. On the other hand, the plot of the life of art entails a verdict of death. The statue is autonomous in so far as the will that produces it is heteronomous. When art is no more than art, it vanishes. When the content of thought is transparent to itself and when no matter resists it, this success means the end of art. When the artist does what he wants, Hegel states, he reverts to merely affixing to paper or canvas a trademark.

The plot of the so-called "end of art" is not simply a personal theorization by Hegel. It clings to the plot of the life of art as "the spirit of forms." That spirit is the "heterogeneous sensible," the identity of art and non-art. The plot has it that when art ceases to be non-art, it is no longer art either. Poetry is poetry, says Hegel, so long as prose is confused with poetry. When prose is only prose, there is no more heterogeneous sensible. The statements and furnishings of collective life are only the statements and furnishings of collective life. So the formula of art becoming life is invalidated: a new life does not need a new art. On the contrary, the specificity of the new life is that it does not need art. The whole history of art forms and of the politics of aesthetics in the aesthetic regime of art could be staged as the clash of these two formulae: a new life needs a new art; the new life does not need art.

METAMORPHOSES OF THE CURIOSITY SHOP

In that perspective the key problem becomes how to reassess the "heterogeneous sensible." This concerns not only artists, but the very idea of a new life. The whole affair of the "fetishism of the commodity" must, I think, be reconsidered from this point of view: Marx needs to prove that the commodity has a secret, that it ciphers a point of heterogeneity in the commerce of everyday life. Revolution is possible because the commodity, like the Juno Ludovisi, has a double nature—it is a work of art that escapes when we try to seize hold of it. The reason is that the plot of the "end of art" determines a configuration of modernity as a new partition of the perceptible, with no point of heterogeneity. In this partition, rationalization of the different spheres of activity becomes a response both to the old hierarchical orders and to the "aesthetic revolution." The whole motto of the politics of the aesthetic regime, then, can be spelled out as follows: let us save the "heterogeneous sensible."

There are two ways of saving it, each involving a specific politics, with its own link between autonomy and heteronomy. The first is the scenario of "art and life exchanging their properties," proper to what can be called, in a broad sense, Romantic poetics. It is often thought that Romantic poetics involved a sacralization of art and of the artist, but this is a one-sided view. The principle of "Romanticism" is rather to be found in a multiplication of the temporalities of art that renders its boundaries permeable. Multiplying its lines of temporality means complicating and ultimately dismissing the straightforward scenarios of art becoming life or life becoming art, of the "end" of art; and replacing them with scenarios of latency and re-actualization. This is the burden of Schlegel's idea of "progressive universal poetry." It does not mean any straightforward march of progress. On the contrary, "romanticizing" the works of the past means taking them as metamorphic elements, sleeping and awakening, susceptible to different reactualizations, according to new lines of temporality. The works of the past can be considered as forms for new contents or raw materials for new formations. They can be re-viewed, re-framed, re-read, re-made. It is thus that museums exorcized the rigid plot of the "spirit of forms" leading to the "end of arts," and helped to frame new visibilities of art, leading to new practices. Artistic ruptures became possible too, because the museum offered

a multiplication of the temporalities of art, allowing for instance Manet to become a painter of modern life by re-painting Velásquez and Titian.

Now this multi-temporality also means a permeability of the boundaries of art. Being a matter of art turns out to be a kind of metamorphic status. The works of the past may fall asleep and cease to be artworks, they may be awakened and take on a new life in various ways. They make thereby for a continuum of metamorphic forms. According to the same logic, common objects may cross the border and enter the realm of artistic combination. They can do so all the more easily in that the artistic and the historic are now linked together, such that each object can be withdrawn from its condition of common use and viewed as a poetic body wearing the traces of its history. In this way the argument of the "end of art" can be overturned. In the year that Hegel died, Balzac published his novel *La Peau de chagrin*. At the beginning of the novel, the hero Raphael enters the show-rooms of a large curiosity shop where old statues and paintings are mingled with old-fashioned furniture, gadgets, and household goods. There, Balzac writes, "this ocean of furnishings, inventions, works of art, and relics made for him an endless poem." The paraphernalia of the shop is also a medley of objects and ages, of artworks and accessories. Each of these objects is like a fossil, wearing on its body the history of an era or a civilization. A little further on, Balzac remarks that the great poet of the new age is not a poet as we understand the term: it is not Byron but Cuvier, the naturalist who could reconstitute forests out of petrified traces and races of giants out of scattered bones.

In the show-rooms of Romanticism, the power of the Juno Ludovisi is transferred to any article of ordinary life which can become a poetic object, a fabric of hieroglyphs, ciphering a history. The old curiosity shop makes the museum of fine arts and the ethnographic museum equivalent. It dismisses the argument of prosaic use or commodification. If the end of art is to become a commodity, the end of a commodity is to become art. By becoming obsolete, unavailable for everyday consumption, any commodity or familiar article becomes available for art, as a body ciphering history and an object of "disinterested pleasure." It is re-aestheticized in a new way. The "heterogeneous sensible" is everywhere. The prose of everyday life becomes a huge, fantastic poem. Any object can cross the border and repopulate the realm of aesthetic experience.

We know what came out of this shop. Forty years later, the power of the Juno Ludovisi would be transferred to the vegetables, the sausages, and the merchants of Les Halles by Zola and Claude Lantier, the Impressionist painter he invents, in *Le Ventre de Paris*. Then there will be, among many others, the collages of Dada or Surrealism, Pop Art and our current exhibitions of recycled commodities or video clips. The most outstanding metamorphosis of Balzac's repository is, of course, the window of the old-fashioned umbrella shop in the Passage de l'Opéra, in which Aragon recognizes a dream of German mermaids. The mermaid of *Le Paysan de Paris* is the Juno Ludovisi as well, the "unavailable" goddess promising, through her unavailability, a new sensible world. Benjamin will recognize her in his own way: the arcade of outdated commodities holds the promise of the future. He will only add that the arcade has to be closed, made unavailable, in order that the promise may be kept.

There is thus a dialectic within Romantic poetics of the permeability of art and life. This poetics makes everything available to play the part of the heterogeneous, unavailable sensible. By making what is ordinary extraordinary, it makes what is extraordinary ordinary, too. From this contradiction, it makes a kind of politics— or metapolitics—of its own. That metapolitics is a hermeneutic of signs. "Prosaic" objects become signs of history, which have to be deciphered. So the poet becomes not only a naturalist or an archaeologist, excavating the fossils and unpacking their poetic potential. He also becomes a kind of symptomatologist, delving into the dark underside or the unconscious of a society to decipher the messages engraved in the very flesh of ordinary things. The new poetics frames a new hermeneutics, taking upon itself the task of making society conscious of its own secrets, by leaving the noisy stage of political claims and doctrines and sinking to the depths of the social, to disclose the enigmas and fantasies hidden in the intimate realities of everyday life. It is in the wake of such a poetics that the commodity could be featured as a phantasmagoria: a thing that looks trivial at first sight, but on a closer look is revealed as a tissue of hieroglyphs and a puzzle of theological quibbles.

INFINITE REDUPLICATION?

Marx's analysis of the commodity is part of the Romantic plot which denies the "end of art" as the homogenization of the sensible world. We could say that the Marxian commodity steps out of the Balzacian shop. That is why the fetishism of the commodity could allow Benjamin to account for the structure of Baudelaire's imagery through the topography of the Parisian arcades and the character of the *flâneur*. For Baudelaire loitered not so much in the arcades themselves as in the plot of the shop as a new sensorium, as a place of exchange between everyday life and the realm of art. The *explicans* and the *explicandum* are part of the same poetical plot. That is why they fit so well; too well, perhaps. Such is more widely the case for the discourse of *Kulturkritik* in its various figures—a discourse which purports to speak the truth about art, about the illusions of aesthetics and their social underpinnings, about the dependency of art upon common culture and commodification. But the very procedures through which it tries to disclose what art and aesthetics truly are were first framed on the aesthetic stage. They are figures of the same poem. The critique of culture can be seen as the epistemological face of Romantic poetics, the rationalization of its way of exchanging the signs of art and the signs of life. *Kulturkritik* wants to cast on the productions of Romantic poetics the gaze of disenchanted reason. But that disenchantment itself is part of the Romantic re-enchantment that has widened *ad infinitum* the sensorium of art as the field of disused objects encrypting a culture, extending to infinity, too, the realm of fantasies to be deciphered and formatting the procedures of that decryption.

So Romantic poetics resists the entropy of the "end of art" and its "de-aestheticization." But its own procedures of re-aestheticization are threatened by another kind of entropy. They are jeopardized by their own success. The danger in this case is not that everything becomes prosaic. It is that everything becomes artistic—that the

process of exchange, of crossing the border reaches a point where the border becomes completely blurred, where nothing, however prosaic, escapes the domain of art. This is what happens when art exhibitions present us with mere reduplications of objects of consumption and commercial videos, labeling them as such, on the assumption that these artefacts offer a radical critique of commodification by the very fact that they are the exact reduplication of commodities. This indiscernibility turns out to be the indiscernibility of the critical discourse, doomed either to participate in the labelling or to denounce it *ad infinitum* in the assertion that the sensorium of art and the sensorium of everyday life are nothing more than the eternal reproduction of the "spectacle" in which domination is both mirrored and denied.

This denunciation in turn soon becomes part of the play. An interesting case of this double discourse is the recent exhibition, first presented in the United States as *Let's Entertain*, then in France as *Beyond the Spectacle*. The Parisian exhibition played on three levels: first, the Pop anti-high-culture provocation; second, Guy Debord's critique of entertainment as spectacle, meaning the triumph of alienated life; third, the identification of "entertainment" with the Debordian concept of "play" as the antidote to "appearance." The encounter between free play and free appearance was reduced to a confrontation between a billiard table, a bar-football table and a merry-go-round, and the neo-classical busts of Jeff Koons and his wife.

ENTROPIES OF THE AVANT-GARDE

Such outcomes prompt the second response to the dilemma of the de-aestheticization of art—the alternative way of reasserting the power of the "heterogeneous sensible." This is the exact opposite of the first. It maintains that the dead-end of art lies in the romantic blurring of its borders. It argues the need for a separation of art from the forms of aestheticization of common life. The claim may be made purely for the sake of art itself, but it may also be made for the sake of the emancipatory power of art. In either case, it is the same basic claim: the sensoria are to be separated. The first manifesto again kitsch, far prior to the existence of the word, can be found in Flaubert's *Madame Bovary*. The whole plot of the novel is, in fact, one of differentiation between the artist and his character, whose chief crime is to wish to bring art into her life. She who wants to aestheticize her life, who makes art a matter of life, deserves death—literally speaking. The cruelty of the novelist will become the rigor of the philosopher when Adorno lays the same charge against the equivalent of Madame Bovary—Stravinsky, the musician who thinks that any kind of harmony or disharmony is available and mixes classical chords and modern dissonances, jazz and primitive rhythms, for the excitement of his bourgeois audience. There is an extraordinary pathos in the tone of the passage in *Philosophy of Modern Music* where Adorno states that some chords of nineteenth-century salon music are no longer audible, unless, he adds, "everything be trickery." If those chords are still available, can still be heard, the political promise of the aesthetic scene is proved a lie, and the path to emancipation is lost.

Whether the quest is for art alone or for emancipation through art, the stage is the same. On this stage, art must tear itself away from the territory of aestheticized life and draw a new borderline, which cannot be crossed. This is a position that we cannot simply assign to avant-garde insistence on the autonomy of art. For this autonomy proves to be in fact a double heteronomy. If Madame Bovary has to die, Flaubert has to disappear. First he has to make the sensorium of literature akin to the sensorium of those things that do not feel: pebbles, shells, or grains of dust. To do this, he has to make his prose indistinguishable from that of his characters, the prose of everyday life. In the same way the autonomy of Schönberg's music, as conceptualized by Adorno, is a double heteronomy: in order to denounce the capitalist division of labour and the adornments of commodification, it has to take that division of labour yet further, to be still more technical, more "inhuman" than the products of capitalist mass production. But this inhumanity, in turn, makes the blotch of what has been repressed appear and disrupt the perfect technical arrangement of the work. The "autonomy" of the avant-garde work of art becomes the tension between two heteronomies, between the bonds that tie Ulysses to his mast and the song of the sirens against which he stops his ears.

We can also give to these two positions the names of a pair of Greek divinities, Apollo and Dionysus. Their opposition is not simply a construct of the philosophy of the young Nietzsche. It is the dialectic of the "spirit of forms" in general. The aesthetic identification of consciousness and unconsciousness, *logos* and *pathos*, can be interpreted in two ways. Either the spirit of forms is the *logos* that weaves its way through its own opacity and the resistance of the materials, in order to become the smile of the statue or the light of the canvas—this is the Apollonian plot—or it is identified with a *pathos* that disrupts the forms of *doxa*, and makes art the inscription of a power that is chaos, radical alterity. Art inscribes on the surface of the work the immanence of *pathos* in the *logos*, of the unthinkable in thought. This is the Dionysian plot. Both are plots of heteronomy. Even the perfection of the Greek statue in Hegel's *Aesthetics* is the form of an inadequacy. The same holds all the more for Schönberg's perfect construction. In order that "avant-garde" art stay faithful to the promise of the aesthetic scene it has to stress more and more the power of heteronomy that underpins its autonomy.

DEFEAT OF THE IMAGINATION?

This inner necessity leads to another kind of entropy, which makes the task of autonomous avant-garde art akin to that of giving witness to sheer heteronomy. This entropy is perfectly exemplified by the "aesthetics of the sublime" of Jean-François Lyotard. At first sight this is a radicalization of the dialectic of avant-garde art which twists into a reversal of its logic. The avant-garde must indefinitely draw the dividing-line that separates art from commodity culture, inscribe interminably the link of art to the "heterogeneous sensible." But it must do so in order to invalidate indefinitely the "trickery" of the aesthetic promise itself, to denounce both promises of revolutionary avant-gardism and the entropy of commodity aestheticization. The avant-garde is

endowed with the paradoxical duty of bearing witness to an immemorial dependency of human thought that makes any promise of emancipation a deception.

This demonstration takes the shape of a radical re-reading of Kant's *Critique of Judgement*, of a reframing of the aesthetic sensorium which stands as an implicit refutation of Schiller's vision, a kind of counter-originary scene. The whole "duty" of modern art is deduced by Lyotard from the Kantian analysis of the sublime as a radical experience of disagreement, in which the synthetic power of imagination is defeated by the experience of an infinite, which sets up a gap between the sensible and the supersensible. In Lyotard's analysis this defines the space of modern art as the manifestation of the unrepresentable, of the "loss of a steady relation between the sensible and intelligible." It is a paradoxical assertion: firstly, because the sublime in Kant's account does not define the space of art, but marks the transition from aesthetic to ethical experience; and secondly, because the experience of disharmony between Reason and Imagination tends towards the discovery of a higher harmony—the self-perception of the subject as a member of the supersensible world of Reason and Freedom.

Lyotard wants to oppose the Kantian gap of the sublime to Hegelian aestheticization. But he has to borrow from Hegel his concept of the sublime, as the impossibility of an adequation between thought and its sensible presentation. He has to borrow from the plot of the "spirit of forms" the principle of a counter-construction of the originary scene, to allow for a counter-reading of the plot of the "life of forms." Of course this confusion is not a casual misreading. It is a way of blocking the originary path from aesthetics to politics, of imposing at the same crossroad a one-way detour leading from aesthetics to ethics. In this fashion the opposition of the aesthetic regime of art to the representational regime can be ascribed to the sheer opposition of the art of the unrepresentable to the art of representation. "Modern" works of art then have to become ethical witnesses to the unrepresentable. Strictly speaking, however, it is in the representational regime that you can find unrepresentable subject matters, meaning those for which form and matter cannot be fitted together in any way. The "loss of a steady relation" between the sensible and the intelligible is not the loss of the power of relating, it is the multiplication of its forms. In the aesthetic regime of art nothing is "unrepresentable."

Much has been written to the effect that the Holocaust is unrepresentable, that it allows only for witness and not for art. But the claim is refuted by the work of the witnesses. For example, the paratactic writing of Primo Levi or Robert Antelme has been taken as the sheer mode of testimony befitting the experience of Nazi de-humanization. But this paratactic style, made up of a concatenation of little perceptions and sensations, was one of the major features of the literary revolution of the nineteenth century. The short notations at the beginning of Antelme's book *L'Espèce humaine*, describing the latrines and setting the scene of the camp at Buchenwald, answer to the same pattern as the description of Emma Bovary's farmyard. Similarly, Claude Lanzmann's film *Shoah* has been seen as bearing witness to the unrepresentable. But what Lanzmann counterposes to the representational plot of the U.S. television

series *The Holocaust* is another cinematographic plot—the narrative of a present inquiry reconstructing an enigmatic or an erased past, which can be traced back to Orson Welles' Rosebud in *Citizen Kane*. The argument of the "unrepresentable" does not fit the experience of artistic practice. Rather, it fulfils the desire that there be something unrepresentable, something unavailable, in order to inscribe in the practice of art the necessity of the ethical detour. The ethics of the unrepresentable might still be an inverted form of the aesthetic promise.

In sketching out these entropic scenarios of the politics of aesthetics, I may seem to propose a pessimistic view of things. That is not at all my purpose. Undeniably, a certain melancholy about the destiny of art and of its political commitments is expressed in many ways today, especially in my country, France. The air is thick with declarations about the end of art, the end of the image, the reign of communications and advertisements, the impossibility of art after Auschwitz, nostalgia for the lost paradise of incarnate presence, indictment of aesthetic utopias for spawning totalitarianism or commodification. My purpose has not been to join this mourning choir. On the contrary I think that we can distance ourselves from this current mood if we understand that the "end of art" is not a mischievous destiny of "modernity," but the reverse side of the life of art. To the extent that the aesthetic formula ties art to non-art from the start, it sets up that life between two vanishing points: art becoming mere life or art becoming mere art. I said that "pushed to the extreme," each of these scenarios entailed its own entropy, its own end of art. But the life of art in the aesthetic regime of art consists precisely of a shuttling between these scenarios, playing an autonomy against a heteronomy and a heteronomy against an autonomy, playing one linkage between art and non-art against another such linkage.

Each of these scenarios involves a certain metapolitics: art refuting the hierarchical divisions of the perceptible and framing a common sensorium; or art replacing politics as a configuration of the sensible world; or art becoming a kind of social hermeneutics; or even art becoming, in its very isolation, the guardian of the promise of emancipation. Each of these positions may be held and has been held. This means that there is a certain undecidability in the "politics of aesthetics." There is a metapolitics of aesthetics which frames the possibilities of art. Aesthetic art promises a political accomplishment that it cannot satisfy, and thrives on that ambiguity. That is why those who want to isolate it from politics are somewhat beside the point. It is also why those who want it to fulfil its political promise are condemned to a certain melancholy.

"The Aesthetic Revolution and Its Outcomes: Emplotments of Autonomy and Heteronomy" by Jacques Rancière, *New Left Review* 14 (March–April 2002), 133–151. Reprinted by permission.

Philosopher and aesthetics scholar Jacques Rancière (b. 1940) is professor emeritus at the department of philosophy of the University of Paris VIII (Saint-Denis). He is the author of numerous essays and books on subjects ranging from politics and the legacy of Marxism to cinema and literature. His interest has more recently shifted toward visual culture and the relationship between politics and aesthetics. He is the author of numerous books, many of which have been translated into English: *Reading Capital* (with Louis Althusser et al., 1968); *The Nights of Labor: The Workers' Dream in Nineteenth-Century France* (1989); *The Ignorant Schoolmaster: Five Lessons in Intellectual Emancipation* (1991); *On the Shores of Politics* (1995); *Disagreement: Politics and Philosophy* (1998); *Short Voyages to the Land of the People* (2003); *The Politics of Aesthetics: The Distribution of the Sensible* (2004); and *Film Fables* (2006). He lives and works in Paris.

EXHIBITION CHECKLIST

1. KAI ALTHOFF
Solo für eine befallene Trompete (Solo for an Afflicted Trumpet) 2005
mixed media
installed dimensions variable
Collection Craig Robins, Miami
Courtesy the artist and ACME, Los Angeles

2. ELLEN GALLAGHER AND EDGAR CLEIJNE
Murmur: Watery Ecstatic, Kabuki, Blizzard of White, Super Boo, Monster 2003
five 16mm film projections (black-and-white/color, silent/sound); edition 5/5
Running time 6 minutes
installed dimensions variable
Courtesy the artist and Gagosian Gallery, New York

3. THOMAS HIRSCHHORN
Cavemanman 2002
wood, cardboard, tape, aluminum foil, books, dolls, cans, mannequins, mannequin
stands, dressmaker forms, Styrofoam heads, wooden figures, posters, videos of
Lascaux, shelves, fluorescent-light fixtures
installed dimensions variable
Courtesy the artist and Gladstone Gallery, New York

REPRODUCTION CREDITS

KAI ALTHOFF
Installation views of *Solo für eine befallene Trompete* (*Solo for an Afflicted Trumpet*)
(2005) at ACME, Los Angeles
Photos courtesy the artist and ACME, Los Angeles
©2005 Kai Althoff
61–75

ELLEN GALLAGHER AND EDGAR CLEIJNE
Film stills from *Murmur: Watery Ecstatic, Kabuki, Blizzard of White, Super Boo,
Monster* (2003)
Photos courtesy the artists and Gagosian Gallery, New York
©2003 Ellen Gallagher
83–85, 87–89, 91–93, 95–97, 99–103

THOMAS HIRSCHHORN
Installation views of *Cavemanman* (2002) at Gladstone Gallery, New York
Photos courtesy the artist and Gladstone Gallery, New York
©2002 Thomas Hirschhorn
109, 112, 115–118, 120–121, 124–127

WALKER ART CENTER
2006–2007 BOARD OF DIRECTORS

Solo für eine befallene Trompete

(Solo for an Afflicted Trumpet)

Kai Althoff

Solo für eine befallene Trompete
(Solo for an Afflicted Trumpet)

Kai Althoff

May 24, 2006

Dear Kai,

It will be great to have some of your input and thoughts regarding *Solo für eine befallene Trompete (Solo for an Afflicted Trumpet)* (2005). We have talked about [Rainer Werner] Fassbinder and his cathartic *Die bitteren Tränen der Petra von Kant (The Bitter Tears of Petra Von Kant)* (1972), which for me seems to be embedded somehow in your installation. I think you told me that this film was important for you. Would you be able to talk about it? Both seem to share concerns such as an emotional involvement, theatrical settings, evocation of sexuality and bisexuality in Fassbinder's film, and a taste for a fin-de-siècle aesthetic involving anachronistic painting references (I am thinking of the [Nicolas] Poussin painting *Midas and Bacchus* [circa 1629] in the movie.)

 I am also wondering if the title of your installation refers to a specific musical moment (maybe Baroque)?

 I would very much appreciate reading your words on this topic; and Yasmil Raymond, the curator working with me on the exhibition, will be in contact with you to facilitate an epistolary conversation.

Very Best,

Philippe

June 22, 2006

Dear Kai Althoff,

I would like to continue the conversation that started with Philippe Vergne's last letter to you by asking a couple of questions about your work and the thinking that guides your aesthetic choices. I have been reading Louis A. Sass' *Madness and Modernism* [:*Insanity in the Light of Modern Art, Literature, and Thought*, 1988], and the opening sentence of his preface made me think of your work: "The madman is a protean figure in the Western imagination, yet there is a sameness to his many masks. He has been thought of as a wild man and a beast, as a child and a simpleton, as a waking dreamer, and as a prophet in the grip of demonic forces." I feel that there are elements of irrationality and sublimation present in your work, particularly in a piece like *Solo for an Afflicted Trumpet*, in which pictures and objects are lying, hanging, and leaning against one another, free of frames or pedestals, in a world where bourgeois codes of order, tidiness, and beauty are suspended. I find that your work evokes a certain portrayal of the world of the madman, its defiance of authority and convention, its exploration of the uncanny, and its obliteration of traditional narrative.

Would you agree with this observation? Why? Could you tell me when you started displaying your work as environments? What role would you like the viewer to take on when they experience the piece? Do you consider your work in keeping with an aesthetic of transgression and experimentation? What were some of the factors that made you make this choice? In your work, I find a dialectical relationship between the mundane and the decadent, the beautiful and the grotesque. Do you consider this dialectic as an aesthetic investigation? I get the impression that the subversive nature of this anti-aesthetic aesthetic, if we can call it that, holds an enormous ambition to rebel against any and every accepted standard of taste, against the clannish nature of artists to form groups, movements, styles. It seems to me that what is at stake is not replacing bourgeois society's values of art by a new one, but instead contesting the very principle of "value."

Yours,

Yasmil Raymond

July 5, 2006

Dear Yasmil, Dear Philippe,

As I haven't answered the question Philippe Vergne asked me in his letter of May 24, I'd like to start with this.

Also I would like to tell you that I suffer from some kind of weird impatience, causing me to be unwilling to answer some questions of the kind you are posing. When I feel insufficient, it only adds to this reaction to answer questions on a level of high cultural and intellectual substance. But I believe all this is no substance—it often seems to be the worst state of voidness a human being could get into.

Simply, I often feel I'd rather keep my mouth shut. Yes, here is a response to what Philippe asked me about the film by R. W. Fassbinder, *Die bitteren Tränen der Petra von Kant*. It is one of the movies I like most in the world and then I also think it's a curse, for often so many of the truth-ridden utterances in this film come to me as I live my own life. I first saw it in 1991. I sensed from the beginning that it contained wholly the "misconcept" and then maybe even "illness" of falling in love with a person who, by nature and set of mind and heart, cannot return this love (this is Karin). Now all such weak understanding is of no use, I see. Feeling how this love returned is envisioned in my imagination, feeding my heart with worldly reassurance, already takes away all freedom of this given love's appearance in form. But despite that, you love that person so much, and want that person to return your love all freely, and wish it to be fulfilled with such urgency—you think you'd rather die than let it go, as it is the only reason to live.

Karin is naturally beautiful and naïve maybe, but she also knows that she is, and that altogether is a gift. And so she lets herself drift into somebody's life (Petra v. Kant's) and wants to get something out of it, too, like Petra, who I believe truly falls in love with her and wants all her ideals to become true. And what I like: though she knows the ways of people, she cannot fight her own love for Karin, which maybe is the only real thing she would like to live for. All talk about career and "learning," becoming "refined"—you can tell she knows what a lie all this is. And yet Karin is only wanting this, and fun. So to me it seems as if Petra is the person who suffers so much. She always has to "find out" and then calm down about the brutality of loving someone and trying to draw this person into one's life, and realizing that, like she says: "People are made not to be alone, but they have not learned how to be together!"

Everything in this film seems to be so much the quintessential truth that I can only bear to look at it because it is so beautifully artificially set in speech and looks that I begin to finally believe that by acting like this, you could overcome the deep sadness that is the subject of this movie. And it takes away all my breath, when in the most tormented moments of hurting, unfulfilled love, Petra says that her work "bores the shit out of her" or that young people are supposed

to develop "their own thoughts," or so she would say, addressing her daughter, that her brightness in knowing all these things is totally no help and of no value when you feel love so much like she does for Karin.

It is hard for me to say, but the more I think about it, the more sad it makes me, as I've come to see that things do really go that way in life. I think of the film and I wonder how one could be so wise to have said so much in this movie, which seems to be almost like an unbreakable, beautiful prison of love, and in the end it leads to the thought that actually one wants to die.

I, of course, love the way it is set. It is so perfect, that I dare say, I would only say one thing: in life, this would already be enough.

But then, yes, there is real life and it may resemble that in this movie or not. The thing that I hate often is that you shift in mood and then you desperately try to find a different angle to look upon the love you feel and you CALM DOWN, like Petra tells her mother at the end of the film, and go on, being taught lessons and so forth. I would like to overcome all these unbearable, narrow (as this is, what it becomes for me) possibilities, and thus don't accept life itself, or the dignity of anything or the endless wish to be happy, or the hope to "calm down." I'm scared, because I can almost see: nothing is safe! Nothing will turn out good! Often all my love unfulfilled is in what I do. My ideal of love is of such a kind that I don't know how to live with it. It makes me feel lonely, but also, rather than not being able to get closest ever to its fulfillment, I won't be able to allow myself less, because that is what "they" and "helping hands in life" would tell you to be satisfied with. To let go of things you love and to calm down. But then I rather don't want life at all.

I like so many things that distract me from this horrible insight that makes me feel imprisoned in a human body in a certain period of time. Then I am surprised as I watch something on TV, like the *Andy Milonakis Show*, which I totally cherish, and I feel: yes, it is alright.

This would have sustained a good feeling for four months or so some time ago, but it now has to be merely fought for. I have to fight for it to win, because the other notion of what all this is meant for is large and sometimes I feel I can't stand it. It all seems so much part of a big plan by some power of evil or good, I cannot tell, because I am often thinking some things I considered to be perceived as evil by society, but they feel nice and beautiful to me, almost closest to that fulfillment of a love that I think is *holy*, evil or not. And I cannot tell. If you allow yourself to differentiate between good or evil, you either are *evil* in a good way, as if you'd believe you are *God*, or in a bad sense, which is when you consider yourself a *wise* person who has gained wisdom by following society's tracks of becoming educated, become a well-adapted member of a certain academic class, and so forth.

I love the film, too, because then all the most painful horrid complexity that one feels is shown in a place that has been arranged to be mundane, beautiful, tasteful living. And all the objects in it seem to ease the hurting wounds this

love has caused. They turn ridiculous at the same time because of their feeble-
ness, though being what you have gained and seemingly the only thing that is
safe. You can always tell they don't mean anything in the end to this love, but
they ridicule the human being in a sad situation.

That is, they are alive and made for some purpose so feeble and then,
when all has fallen apart, they are still there and transformed by your own feel-
ings. If I had the doll Petra v. Kant owns, the one that sits on the beams of the
timber structure, I would feel all her sadness held within it forever.

I love Petra von Kant, and she is the one I would think could go off and
really leave these circumstances and form her own being and become everything.
This seems to be the option in the end of the film, too.

So I think Solo für eine befallene Trompete is maybe to be thought about
in the same way as one would think about the interior of P. V. K.'s house. But yet
this is my house, and my love differs from her wishes, I guess quite a lot. But also,
while I was painting, drawing, or proceeding to collect the things that would fill
my small apartment where I work, if you call this work, I did not think of Petra
von Kant any more. This is a long time ago that I have been watching the movie,
and it is very much part of what I am thinking about probably all the time. I
started for the second time to buy all the things that I liked so much to be part
of my life: objects all over, until they became so many that they would have bur-
ied me if I did not stop, maybe.

I too have always secretly drawn many times things that I would want to
be part of sexually, or that I admired because of their highest sexual and mental
power over me. All highest power includes sexual power for me. So I'd often have
many drawings of some men who most of the time were supposed to be like icons.
But when I looked at them, I always destroyed them at a certain point. I never
showed them to anyone. Also I used to masturbate when I looked at them, but I
knew that if I were to keep them, they would take over more and more.

Sometimes they do take over. And in this exhibition I began to try to do
other things, but then I started to do some of these drawings up to a certain point,
and forced myself partly to keep them, but also I was no longer interested AT
ALL in doing anything else. I wanted to do a painting that was free of all these
thoughts, but could not. So I somehow did all this, and to me all these things that
I had collected became like the interior of a house with many persons living in
it, in which all are forced to work to serve the will of Satan. He splits into many
characters, each one containing his wish to triumphantly rule over all sexuality,
and over all thoughts.

It's all warm and pleasant to a point where I do give up. It is then like a
whorehouse maybe, where you'd have to bow to his total will and to the will of
his friends.

I truly loved some of the dolls, especially one so much, I wanted to keep
her from that, but then I also realized they're not in danger. I did not touch some,
and other things he would touch. As if he wouldn't want to scare you too much

or seduce you so very sly, he'd always have his sexuality of such kind that you'd like it and would always want to be absorbed entirely by it. There is also no way here for me to say whether it is evil. I think it is Satan, but I cannot believe that when he makes you like it that it is wrong.

As if to present to him my feeble—by society ever so often called false—ability to fall in love with a man only, I am forced to sew dresses like haute couture and believe I will be killed by him when I would wear these, which I like very much.

He confronts me with all these frilly beautifully shiny things as if to degrade me and to tell me that I am playing with this like some girl. But then he also lets me do this and offers older woman to let me know about sexuality. In the end he moves around this house he built and will fill my body with all these things, and dresses me up to look ridiculous, as if I had been trying to look like a woman. He will always go far, but keeps me from dying or disbelieving in God entirely, too. He would then give me the doll back or something and leave me for some days to be free, feeling all the time that I am all his possession and so on.

Well, this is just a very overall view into that; also I wished so much that I could explain certain things much better and more accurately. All notions are very precise in the end, and also they are not to be told.

Like when I say he'll fill me with those things, he'd mix chocolate with his urine and feed it to me for four days, but crush my most beloved doll, too, so it breaks into a million pieces in order to mix it with that to feed me further. And then I would know, it is all the only thing I ever want to live for, too.

If the best happens, the viewer is allowed to live with the things I "display," as you say. Now I would not want everyone to live in it, but certainly a few, or I would always be happy if I would find the viewer being part of what I believe to happen here. If someone tells me he feels all that I have said above, he'd be my friend.

I know of decadence but as a matter of fact, Satan applies all this decadence of my taste on me to degrade me as a weak and utterly feeble person. And yet he moves among this taste with care, too. But his triumph is his appearance in geometric form. He is beyond all known formal appearance, but closest to our ability of imagination would be one of geometric form.

Now all this I wrote down with no particular care on structuring or trying to really explain anything, also taking into account that I feel limited by the use of the English language. It may answer some questions, or raise further questions. I am aware that I have not answered some of those you've posed, but then I don't reflect on what I do while I am doing it, and don't want to be reflecting on it later, either. I highly value all the things that are included in this environment, knowing that they may not be valuable for anyone else. Especially I wonder: it does not help anyone, maybe. But certainly, I think, then it helps me to love. I have not always had so strong a realization that I do things to love something the way I wish I'd be loved.

This often makes all other things seemingly of no importance, like caring for others. But maybe I care for some properly, without any thoughts of selfishness. Which I hate about me, then, that it all seems to be about myself. But I'll be damned if this is true.

Yours sincerely,
Well, I do hope you are very well.

Kai

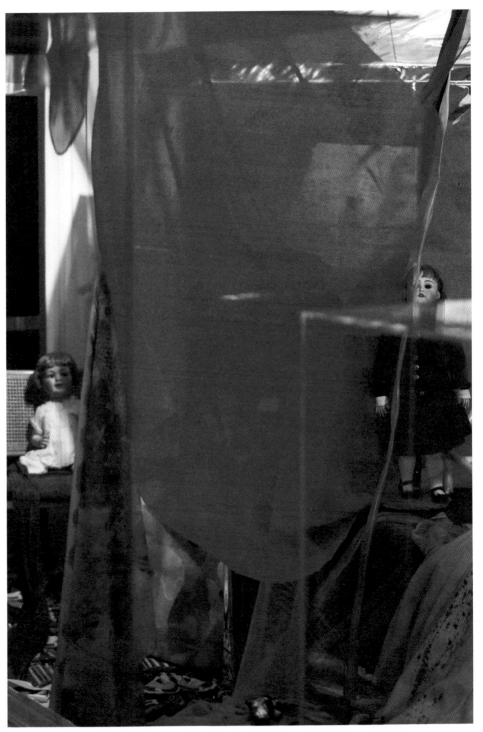

All images: Kai Althoff *Solo für eine befallene Trompete (Solo for an Afflicted Trumpet)* 2005

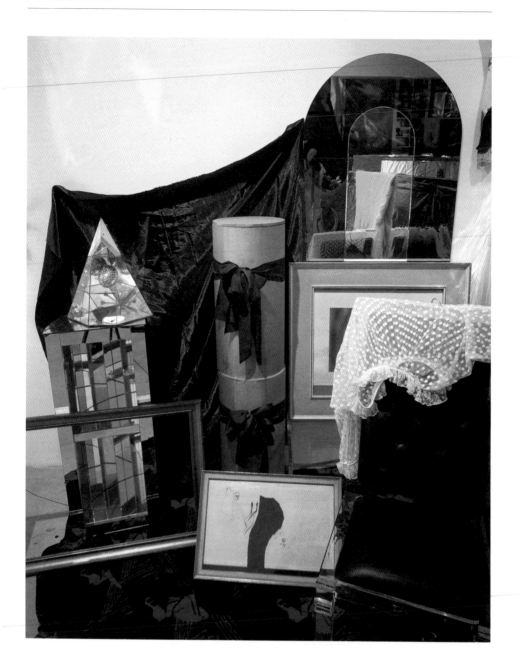

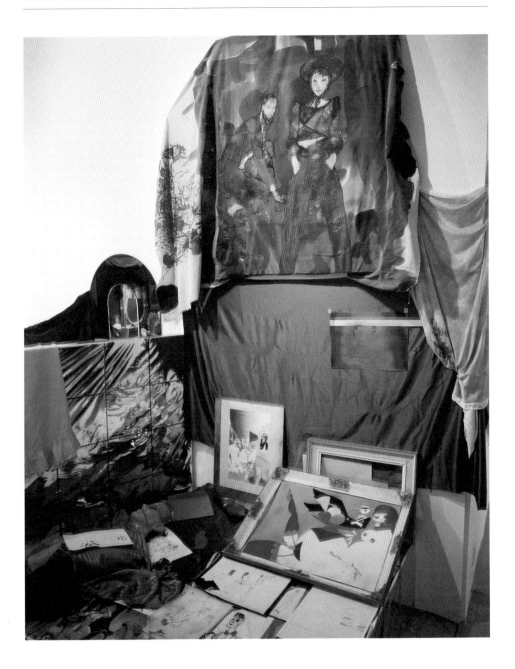

63 Solo für eine befallene Trompete (Solo for an Afflicted Trumpet)

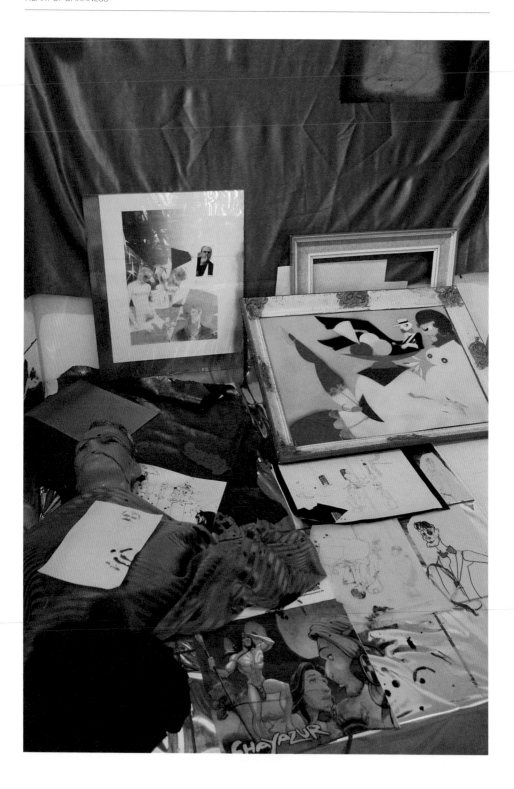

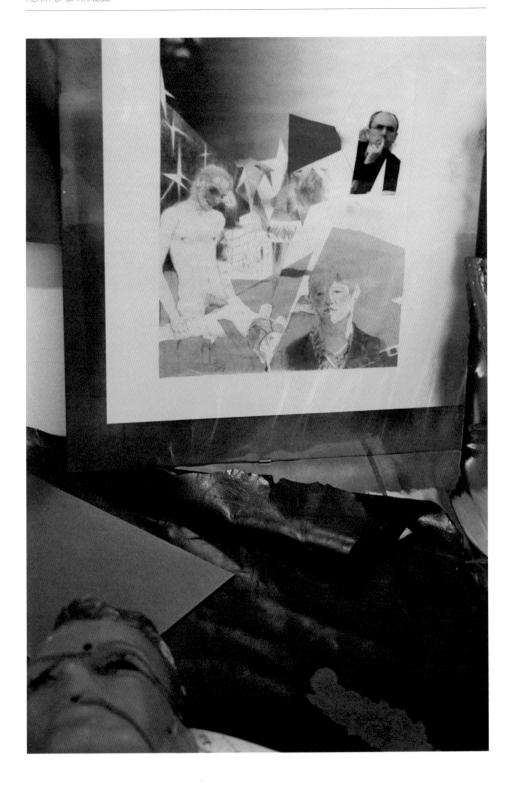

65 Solo für eine befallene Trompete (Solo for an Afflicted Trumpet)

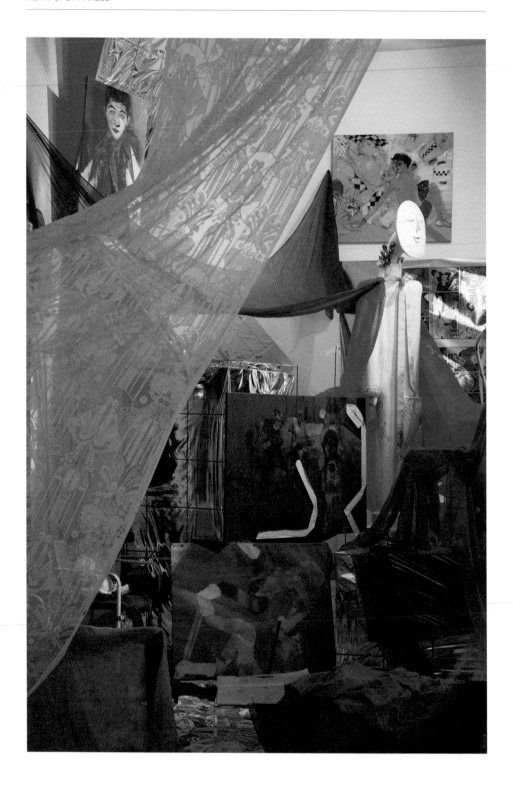

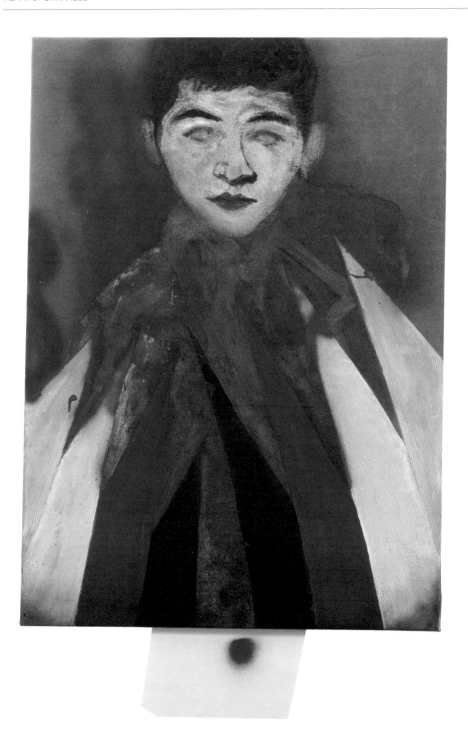

67 Solo für eine befallene Trompete (Solo for an Afflicted Trumpet)

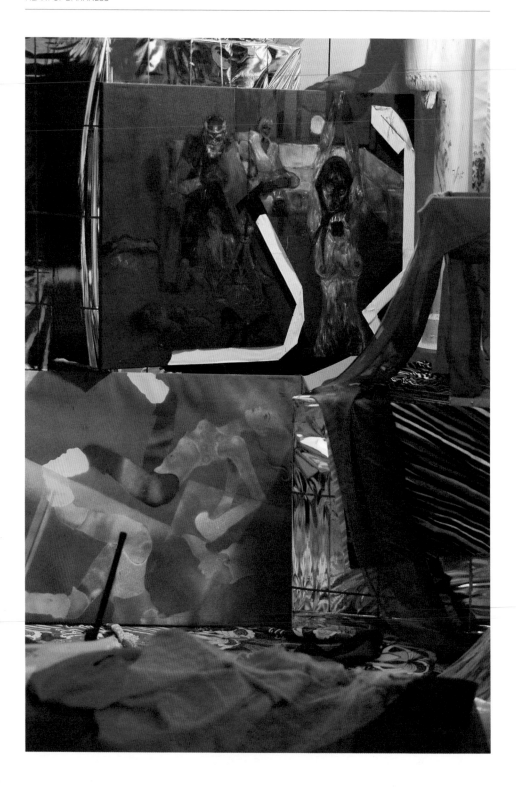

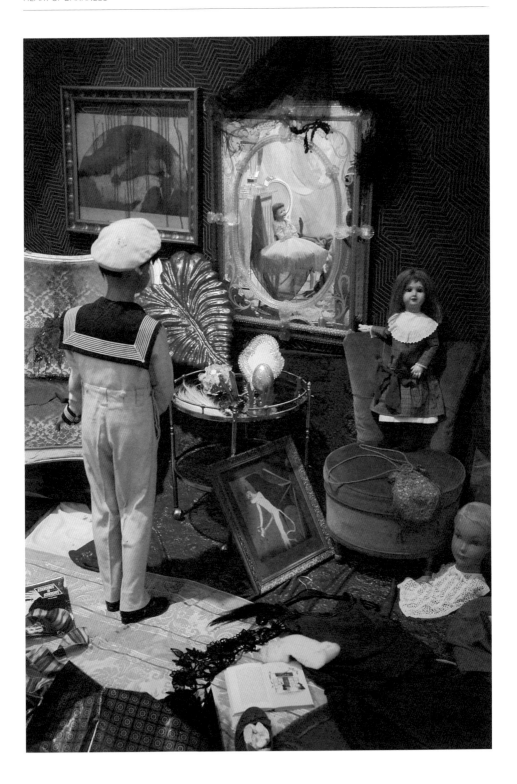

69 Solo für eine befallene Trompete (Solo for an Afflicted Trumpet)

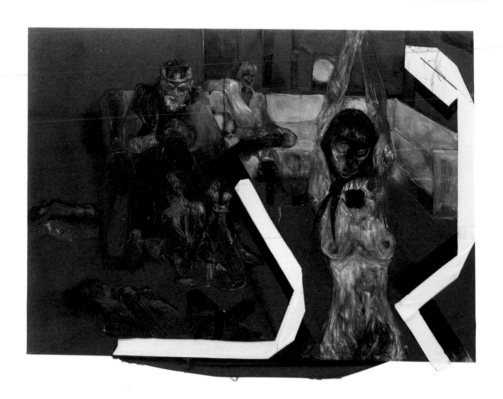

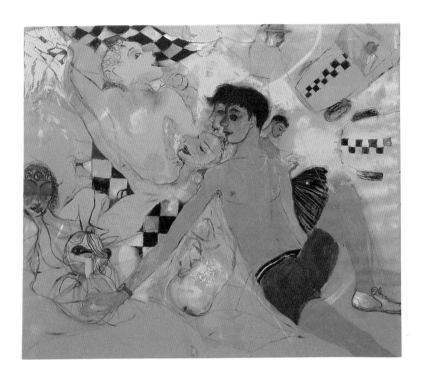

71 Solo für eine befallene Trompete (Solo for an Afflicted Trumpet)

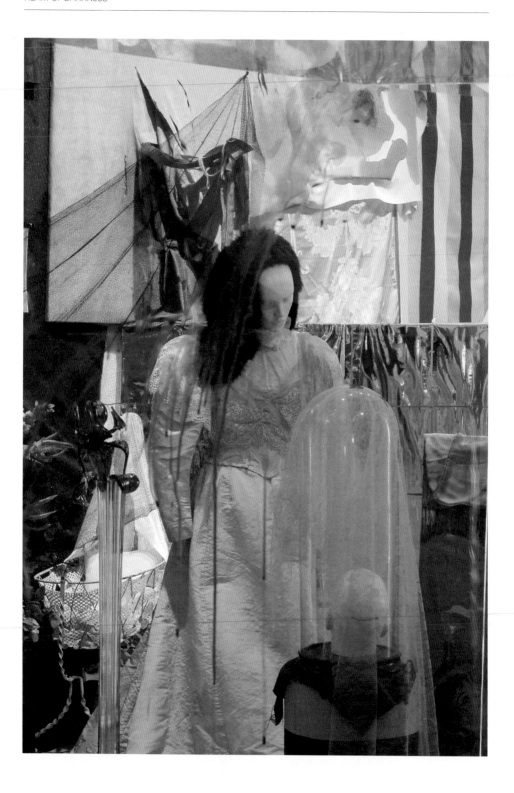

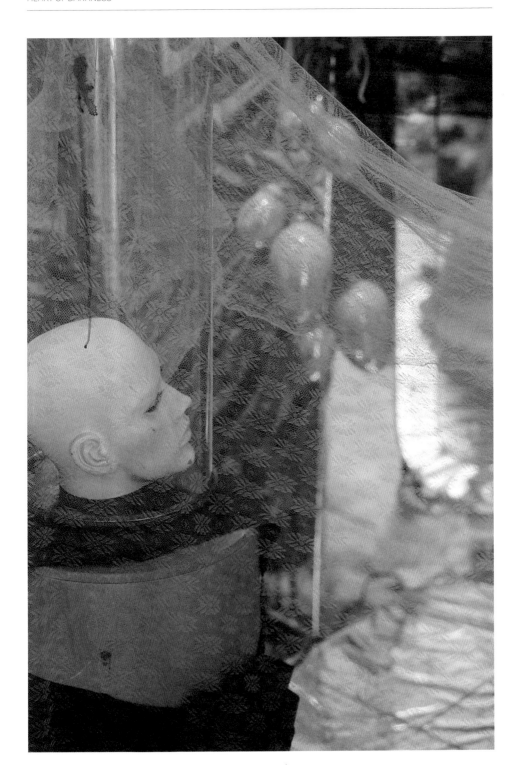

73 Solo für eine befallene Trompete (Solo for an Afflicted Trumpet)

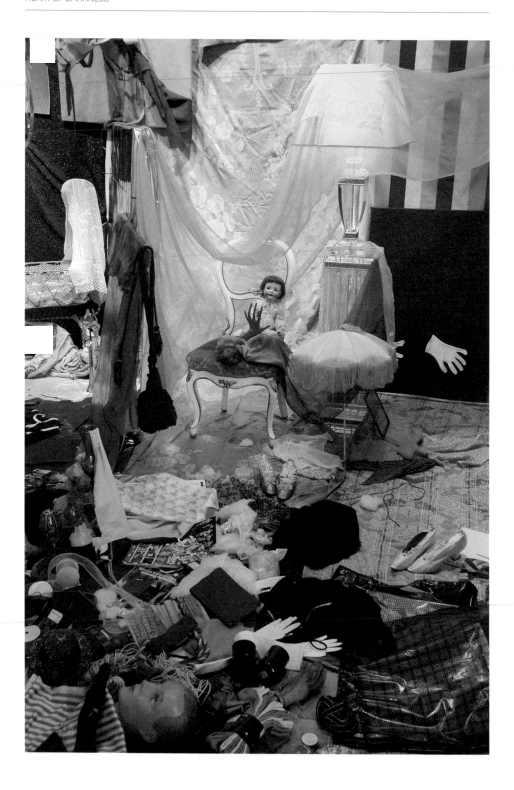

75 Solo für eine befallene Trompete (Solo for an Afflicted Trumpet)

Kai Althoff
Born 1966, Cologne, Germany
Lives and works in Cologne

Selected Solo Exhibitions

2005
Solo für eine befallene Trompete, ACME,
Los Angeles

2004
Kai Althoff: Kai Kein Respekt (Kai No Respect),
Institute of Contemporary Art, Boston; Museum
of Contemporary Art, Chicago. Catalogue.

Immo, Simultanhalle, Cologne

2003
Vom Monte Scherbelino Sehen (with Abel Auer),
Diözesanmuseum, Freising, Germany

2002
Kai Althoff (with Armin Krämer), Kunstverein
Braunschweig, Germany. Catalogue.

2001
Impulse, Anton Kern Gallery, New York

Aus Dir, Galerie Daniel Buchholz, Cologne

2000
Stigmata aus Großmannssucht, Galerie Ascan
Crone, Hamburg, Germany. Catalogue.

Hau ab, Du Scheusal, Galerie Neu, Berlin

Selected Group Exhibitions

2006
Painting in Tongues, Museum of Contemporary
Art, Los Angeles. Catalogue.

Von Mäusen und Menschen / Of Mice and Men,
4th Berlin Biennial, Berlin. Catalogue.

*Optik Schröder: Werke aus der Sammlung
Schröder*, Kunstverein Braunschweig

2005
The Blake Byrne Collection, Museum of
Contemporary Art, Los Angeles. Catalogue.

The Triumph of Painting, Saatchi Gallery,
London. Catalogue.

2004
supra caput esse, Corvi-Mora, London

Sans Soleil, Galerie Neu, Berlin

From Aural Sculpture to Sound by Ink, Galerie
Art: Concept, Paris

2003
Pittura/Painting, 50th International Art Exhibition,
Venice Biennale, Venice. Catalogue.

Malerei II Ausstellung Nulldrei, Galerie Nagel,
Cologne

2002
Chére Paintre, Liebe Maler, Dear Painter, Centre
Georges Pompidou, Paris; Kunsthalle Vien,
Vienna; Schirn Kunsthalle, Frankfurt. Catalogue.

Drawing Now: Eight Propositions, Museum of
Modern Art, New York. Catalogue.

2001
Drawings, Regen Projects, Los Angeles

Neue Welt, Frankfurter Kunstverein, Frankfurt

2000
Drawings 2000, Barbara Gladstone Gallery,
Barbara Gladstone, New York. Catalogue.

Selected Bibliography

Baume, Nicholas, et al. *Kai Kein Respekt (Kai
No Respect)*. Exh. cat. Boston: Bridge House
Publishing and Institute of Contemporary Art,
Boston, 2004.

Eichwald, Michaela, and Kai Althoff. *Kai Althoff:
Stigmata aus Großmannssucht (Kai Althoff: The
Stigma of Craving for Status)*. Exh. cat. Hamburg:
Galerie Ascan Crone, 2000.

Gustorf, Oliver Koerner von. "Super Creeps:
Cruising through the Work of Kai Althoff."
Parkett 75 (2005): 90–101.

Kantor, Jordan. "The Ties That Bind." *Parkett* 75
(2005): 68–77.

Loers, Veit. "With Bellbottoms in the Underworld."
Parkett 75 (2005): 78–95.

Schafhausen, Nicolaus, ed. *Kai Althoff: Gestures
and Expressions*. Frankfurt: Lukas & Sternberg,
2002.

Steiner, Peter B., and Petra Giloy-Hirtz, eds. *Vom
Monte Scherbelino Sehen: Kai Althoff & Abel
Auer*. Regensburg: Schnell & Steiner, 2003.

MURMUR
Watery Ecstatic
Kabuki
Blizzard of White
Super Boo
Monster

Ellen Gallagher and Edgar Cleijne

MURMUR
Watery Ecstatic
Kabuki
Blizzard of White
Super Boo
Monster

Ellen Gallagher and Edgar Cleijne

THE MEMORY OF WATER
Philippe Vergne

In a 1988 article on the memory of water, French immunologist Jacques Benveniste attempted to demonstrate that water can contain the "memory" of particles dissolved in it. Such a memory allows water to retain the property of the original solute even when there is literally nothing left in the solution. This fascinating theory has been dismissed by mainstream science as pseudoscience, but it holds a real poetic value. When I think of *Murmur: Watery Ecstatic, Kabuki, Blizzard of White, Super Boo, Monster* (2003), the collaborative film installation by Ellen Gallagher and Edgar Cleijne, I cannot help but think that they might have given the memory of water its real meaning far away from the world of science.

Murmur includes five 16mm animated films, shown concurrently and continuously looped. *Watery Ecstatic* is a stop-action film based on the rudimentary animation of "wigladies," a motif Gallagher used in a 1997 painting titled *Drexciya*. As Caoimhín Mac Giolla Léith has written,[1] the title was inspired by the name of a Detroit underground house band that conceived of its music as "channeling aural hallucinations of Drexciya, a mythic underwater land in the mid-Atlantic populated by women and children who leapt from the slave ships during the course of the perilous Middle Passage, the most grueling part of the slave journey from Africa to America."[2] The iconography of the painting was composed of Gallagher's lexicon of visual motifs gleaned from the debased signifiers of race once associated with the tradition of blackface minstrelsy—the big eyes, thick lips, long tongues, bow ties, and flipped wigs. These paper-made, animated wigladies are shown in an in-between location, floating at the foaming surface of the sea before being absorbed in its unfathomable depths.

Blizzard of White, an inky graphite drawing, takes us to the bottom of a dark volcanic sea where we are met by a flock of plasticine organisms, hallucinated wigladies, octopuses, and starfish. *Kabuki* is a more sophisticated stop-action film featuring a 3-D digital animation of a fractal, fragmented wiglady slowly looping down into Drexciya. For *Monster*, Gallagher and Cleijne have appropriated Jack Arnold's 1953 B-movie *It Came from Outer Space*, a stereotypical Cold War science-fiction invasion, abduction, and body-snatching tale. The artists have reworked and scratched the original footage, giving its protagonists long blond hair and hallucinogenic eyes. Set in a desert, on an empty road at night, the scenes are interrupted by flickering screen titles spelling, in sequences, the following message: "What happened? What happened? What happened? Don't be afraid. It is within our power to look like you or anyone. For a time it will be necessary to do this." In this fictional world, the aliens—the others—all appear to be monstrously white and blond. The scratched images then create a parallel narrative that moves along and hijacks the already existing one.

Super Boo also falls along the lines of detournement and appropriation of already existing signs and data, which Gallagher generated herself. It is a stop-action animation that takes one of the artist's drawings from her *Ebony* series as ground. Preexisting images are reactivated by the camera to create a fight sequence

Watery Ecstatic (Murmur) 2003 film stills

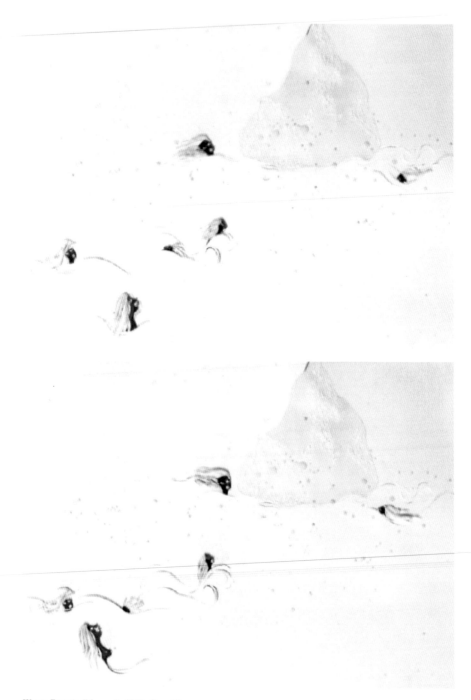

Watery Ecstatic (Murmur) 2003 film stills

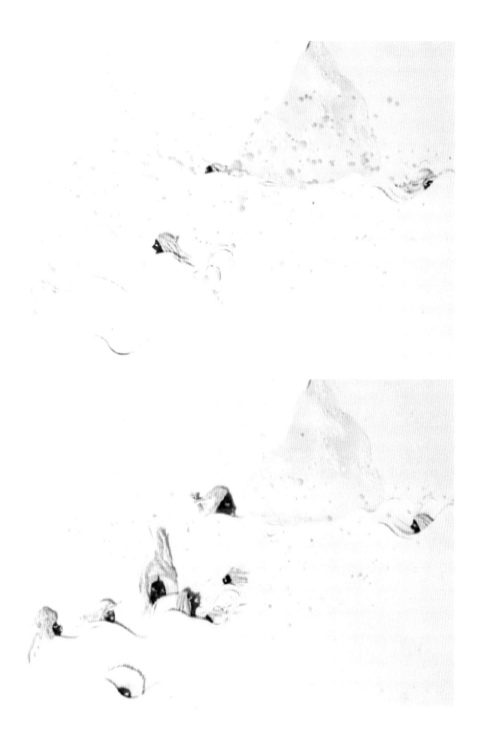

between Bruce Lee and Jim Kelly. The series was stirred and informed by the Lee "Scratch" Perry sound track for the 1975 film *Enter the Dragon*, which serves as a narrative for the battle between the actors. To add to the layering of images, references, and symbols that *Murmur* combines, the track itself is extracted from a Dizzee Rascal sample of Javanese gamelan music.

Super Boo is both the crest and the opening "credit" of an installation that is thought through as a film. As the first thing one encounters when entering the space, it sets the tone for a journey that gives history, myth, autobiography, and fiction a form that the artists themselves have described as follows: "The physical form of *Murmur* is a singular entity made up of several parts that have the properties of expressive phrasing rather than a narrative structure. The various forms within [it] are modulated to create emphasis. This applies to *Murmur* as a whole as well as to the way forms are combined within the individual 16mm projections that make up [the work]. Disparate materials are combined and transformed within the individual projections."[3]

As a form, *Murmur* is an alien. It is the fruit of a collaboration between two artists known for very different work, though the smallest common denominator of their practices has fed *Murmur*. They both left the comfort zone of their practices to meet in a location where they had to literally invent a technique that gave birth to the project. They had to become alien to themselves in order to actually challenge the way they represent themselves and to initiate meaning through their work. They had to delimit an area in which what they are known for does not apply anymore. They went through a mutation process and abduction of self that finds no better equivalent than the process of mutation and abduction at the center of *Murmur*, which is the trauma generated by a descent, either mythic or real, into Drexciya. Both have muted their authorship without losing their voices.

Gallagher has been known since the early 1990s for a body of work in which she brings together different traditions that, according to the canon of the modernist aesthetic, were incompatible or not necessarily meant to meet. In paintings, drawings, and prints she has used seriality and repetition in a manner that could suggest the legacy of Minimalism. But her use of seriality reminiscent of the 1960s movement might have been a strategy whose goal was to undermine a stereotype that signified a Euro-American modernity, or style. Seriality, repetition, and grid are at the center of an aesthetic that, as art historian Rosalind Krauss pointed out, announced the desire of modern art to become silent, to turn its back on narrative, literature, discourse, and eventually history. Gallagher perverted such an agenda and insufflated this aesthetic with a voice, an alien voice whispering that it is time for artists to reconsider narratives, and that narrative could convey and debunk a myopic, biased history. She does it by inserting into this paradigm her own syntax and language, which includes faces with exaggerated eyeballs and lips, stereotypically African American hairdos, and a set of features that have been used, if not abused, to depict "black" visages. More recently, she also manipulated advertising images extracted from magazines such as *Ebony*, *Our World*, and *Black Stars*, and gave them a plasticine "wiggery do," exploring coiffure as a racialized emblem.

Kabuki (Murmur) 2003 film stills

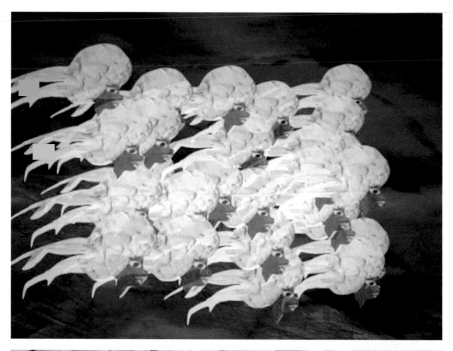

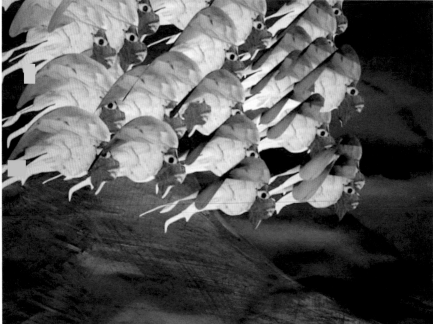

Kabuki (Murmur) 2003 film stills

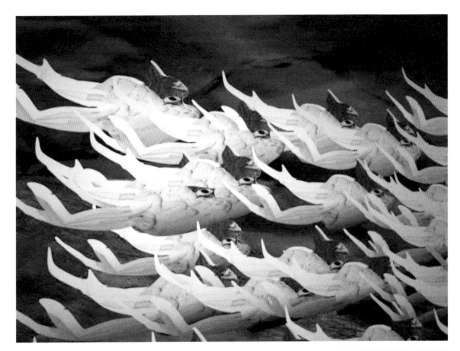

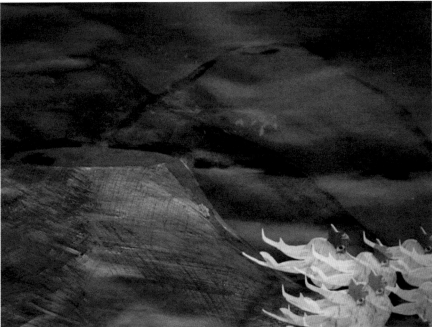

Cleijne is a photographer, a filmmaker, and above all, a traveler. His photography and film work took him to, among other places, West Africa. His work is a meditation on human intervention and activities that ranges from a macro to a micro level, from aerial views of urban areas to the intimacy of office interiors, often deserted but bearing signs of individuals' presence. Through his witnessing of living and working conditions, Cleijne is giving testimony on rapid, sometime cruel, urban growth and migration in West African cities, and the environmental fragmentation and degradation that accompanies such a movement when poor planning and ineffectual control of land use are at play. Overall, his images, neither compassionate nor distant, stress that facts can carry a sense of layered narrative, if not fiction, which can make bearable the trauma of a reality wounded by migration and adversity.

Artist Daan Van Golden, who spent his life traveling, once said that "travel neutralizes ambition." It might be a key idea to enter and understand an artistic collaboration about migration and displacement, thought of as a journey; and a collaboration that started as a journey. According to the artists, *Murmur* originated during a trip to the Italian volcanic island of Stromboli, where they witnessed the lava and rock formation slipping from the mountain to the sea and the underwater world. The coincidence, or not, is that the Roberto Rossellini film *Stromboli* (1950) is itself the tale of a distressing dislocation that takes place on the steaming slope of the volcano.

Gallagher and Cleijne are taking themselves and their viewers on a journey that embraces the myth of the underwater world—a myth that extends itself from the primordial Nu of Egyptian cosmogony (the aqueous location that contained within itself all the elements of a world to come) to Drexciya to Paul Gilroy's Black Atlantic as it stands for an alternative history of modernity, where culture is not specifically African, American, Caribbean, or European.[4] When he considers a culture where one could rise above ethnicity and nationality, Gilroy analyzes music as a vehicle that spread a racial message in a "transatlantic" way, and links it to the writing and theories of black authors such as W.E.B. Du Bois and Toni Morrison. The result is a microcosm in which history, music, and theory murmur and whisper the possibility of a change, of a displacement of narratives.

The politics of displacement might be what animates *Murmur* as its content and its formal structure echo the modality of a disembodiment at many levels. It starts from a microcosm, the one Gallagher gives life to in her *Watery Ecstatic*[5] drawings, and the one she discovered through Sigmund Freud's drawings related to his interest in marine biology and Darwin. Freud acknowledged that he became a medical student out of his awareness of Darwin's theories. He explored the early forms and origins of the nervous system in order to better understand their evolution and discovered that specific cells of primitive fish were strangely similar to those of more evolved animals, so he was able to establish the validity of an evolutionary continuity and mutability in the nerve structure. Freud illustrated his observation through a series of drawings that shared an almost formal similarity with the singled-celled free-swimming organism, a "blizzard of white" that occurs in all the world's oceans—the "radiolarians" documented in the late nineteenth

Blizzard of White (Murmur) 2003 film stills

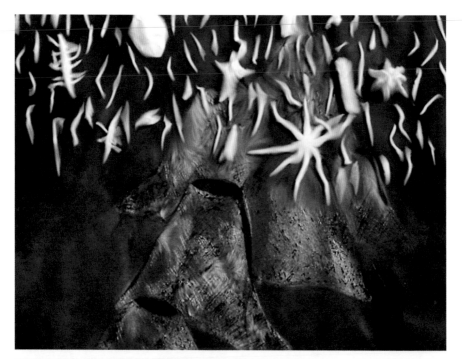

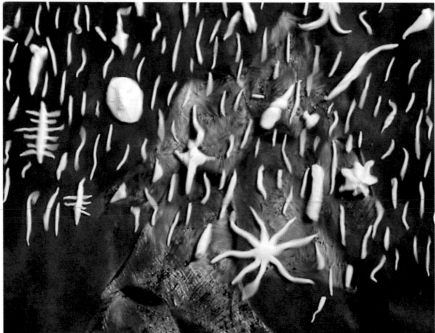

Blizzard of White (Murmur) 2003 film stills

93 Murmur: Watery Ecstatic, Kabuki, Blizzard of White, Super Boo, Monster

century by zoologist Ernst Haeckel. Both Haeckel's radiolarians or Freud's "spinal ganglia and spinal cord of Petromyzon," which adds a stone to the theory of evolution, are to be found in the DNA of Gallagher and Cleijne's *Murmur* and its mutable structure and iconography.

The "wigladies" are the variable cells of racial awareness and history. They are the displaced bodies of the slaves who disappeared, through murder or voluntary death, in the water of the Middle Passage; they are the androids, the aliens who found refuge in Drexciya and feed the social and political sea change of Euro-American modernity.

The virtue of the installation is actually its openness about the topic or topics it covers or uncovers. And the topics are numerous, particularly the formal ones, which range from image appropriation to content detournement. *Murmur* is a vortex with multiple axes that put in motion the stability of history and its forms, as well as the history of the forms, in order to address, or to whisper, that the present, when fictionalized by history, could be what the late François Mitterand named a "permanent revolution,"[6] literally and of course metaphorically.

The structure of the installation itself is a visual, if not architectural "revolution"; it is the architecture of a vortex. By alternating found footage of "real" situations (*Monster*), appropriated iconography (*Super Boo*), and stop-action animated films (*Kabuki, Blizzard of White, Watery Ecstatic*), the shivering repetition of motifs and sounds produces a mind-twister that confuses the nature of perception. Cleijne, in this matter, quotes the research led by neuroscientists who study ways that cartoons and video clips affect different areas of the brain.[7] Neuroscientists have used Richard Linklater films (*Waking Life*, 2001; *A Scanner Darkly*, 2006), in which the director blurs the distinction between reality and animation, as a case study to understand the modality and effects of perception.

By collapsing animation and film footage, Gallagher and Cleijne are affecting our reaction to the images and our understanding of them. The brain, noticed the scientist, can swallow almost anything, provided it comes in the form of a story. Here the artists simulate such a form, and therefore affect what the story is supposed to tell us. The story takes us to a heart of darkness where a multiplicity of narratives is juxtaposed to elaborate an interrupted structure in which fiction and history merge in a vortex. This form and its content, the narrative of artists in a post–Civil Rights area, might echo the literary form that Joseph Conrad gave to *Heart of Darkness*, in which fiction, history, and critical theory collide to unveil the genocides of his own time. Even more convoluted is Sven Lindquist's book *"Exterminate All the Brutes,"*[8] which tells of a man traveling by bus through the Saharan desert who is simultaneously investigating and taking an intellectual journey through the history of extermination. It traces the legacy of European explorers, missionaries, politicians, and historians in late eighteenth-century Africa that sets Conrad's *Heart of Darkness* in context and contributes to an understanding of the most horrifying of Conrad's turns of phrase: "Exterminate all the brutes." A story rather than a contribution to historical scholarship, Lindquist's book adopts a fragmented form. It gives a written

Super Boo (Murmur) 2003 film stills

Super Boo (Murmur) 2003 film stills

equivalent to his perception of history as a nonlinear narrative, a labyrinthine structure in which one is invited to step to the side in order to move forward. In his book, not unlike *Murmur*, history is not experienced as a forgone conclusion. Both proffer an experience of the uncertainty of history, which leads to the acceptance of the present as a passage.

For Gallagher and Cleijne, fragmentation takes the form of a montage in the space; the meaning rises in between each projection, which are themselves installed in a mazelike structure. The interval or the distance between each film undoes the linear logic of a narration. Fragmentation, cuts, collage, and juxta-position are used here to facilitate the meeting of incompatible signs and images (Bruce Lee and Jim Kelly, Drexciya and aliens from outer space). *Murmur* arranges and stages the poetic value of heterogeneity that according to philosopher Jacques Rancière[9] constitutes "le montage dialectic," which reveals the secret of a world.

Such a secret might be the one contained in the blizzard of white that composes the memory of water, of the atrocious actuality of the Middle Passage as the ultimate alien abduction in which one is displaced, disembodied, robbed, dismembered. The memory of water could very well be the history of forgetting an unnamed and continuous movement of quotidian genocide that camouflages itself under the disguise of anodyne representations. *Murmur* might murmur that in the process of evolution, one can never remember enough.

NOTES

1. See Caoimhín Mac Giolla Léith in Ellen Gallagher's artist's book *Orbus* (Edinburgh: Fruitmarket Gallery, 2005).
2. Ibid.
3. From an e-mail exchange between the author and the artists, July 26, 2006.
4. Paul Gilroy, *The Black Atlantic: Modernity and Double Consciousness* (Verso: London and New York, 1993; reprint edition, Cambridge, Mass.: Harvard University Press, 2005).
5. Léith reminds us in his essay about Gallagher's work that "to be ecstatic (from the Greek *ekstasis*, meaning a displacement or dislocation) is to be caught up in a rapturous transport."
6. Permanent Revolution, a phrase coined by Karl Marx in 1850, is a Marxist theory most closely associated with Leon Trotsky and the title of his 1929 book.
7. See John Whitfield, "An MRI scanner darkly," in *Nature* 441, June 2006. In this article, Whitfield looks at ways that a cinematographic technique can provide insights into the perception of reality.
8. Lindquist's book *"Exterminate All the Brutes": One Man's Odyssey into the Heart of Darkness and the Origins of European Genocide* (New York: The New Press, 1996) was recommended to the author by Gallagher and Cleijne during a discussion of the *Heart of Darkness* exhibition and the meaning of *Murmur*.
9. See Jacques Rancière, *Le Destin des Images* (Paris: La Fabrique Editions, 2003), in which he discusses "le montage dialectic."

Monster (Murmur) 2003 film stills

Monster (Murmur) 2003 film stills

Monster (Murmur) 2003 film stills

ELLEN GALLAGHER was born in Providence, Rhode Island, in 1965, and studied at Oberlin College, Ohio (1984), School of the Museum of Fine Arts, Boston (1992), and Skowhegan School of Painting and Sculpture, Maine (1993). Her most recent solo exhibitions include: *Salt Eaters*, Hauser & Wirth, London (2006); *DeLuxe*, Whitney Museum of American Art, New York (2005); *Ichthyosaurus*, Freud Museum, London (2005); *DeLuxe*, Museum of Contemporary Art, North Miami (2005); *eXelento*, Gagosian Gallery, New York (2004); *Ellen Gallagher, Orbus*, Fruitmarket Gallery, Edinburgh (2004); *Current 88: Ellen Gallagher*, Saint Louis Art Museum, St. Louis (2003); *Preserve*, Des Moines Art Center, Iowa, Yerba Buena Center for the Arts, San Francisco, and the Drawing Center, New York (2001–2002); and *Watery Ecstatic*, Institute of Contemporary Art, Boston (2001). Group exhibitions include: *Infinite Painting: Contemporary Painting and Global Realism*, Villa Manin Centre for Contemporary Art, Passariano-Codroipo, Italy (2006); *Alien Nation*, Institute of Contemporary Arts, London (2006); *Black Panther Rank and File*, Yerba Buena Center for the Arts, San Francisco (2006); *Skin Is a Language*, Whitney Museum of American Art, New York (2006); *The Fluidity of Time: Selections from the MCA Collection*, Museum of Contemporary Art, Chicago (2005); *Double Consciousness: Black Conceptual Art Since 1970*, Contemporary Arts Museum, Houston (2005); *Don't Touch the White Woman*, Fondazione Sandretto Re Rebaundengo, Turin, Italy (2004); *Disparities and Deformations: Our Grotesque*, SITE Santa Fe Fifth International Biennial, Santa Fe, New Mexico (2004); *Dreams and Conflicts: The Dictatorship of the Viewer*, 50th International Art Exhibition, Venice Biennale (2003); *The Mystery of Painting*, Sammlung Goetz, Munich (2002); *The Americans: New Art*, Barbican Gallery, London (2001); and *Greater New York: New Art in New York Now*, P.S.1. Contemporary Art Center, Long Island City, New York (2000). Selected bibliography: *Orbus* (Edinburgh: Fruitmarket Gallery, 2005); *Ellen Gallagher: Blubber* (New York: Gagosian Gallery, 2001); *Ellen Gallagher: Preserve* (Des Moines, Iowa: Des Moines Art Center, 2001); *Ellen Gallagher* (London: Anthony d'Offay Gallery, 2001); and *Ellen Gallagher* (Boston: Institute of Contemporary Art, 2001). In 2000, she received an American Academy Award in Art. She lives in New York and Rotterdam.

EDGAR CLEIJNE was born in Eindhoven, the Netherlands, in 1963, and studied at the Rotterdam Conservatory. Most recently his work has been included in the group exhibitions *Spectacular City: Photographing the Future*, Netherlands Architecture Institute, Rotterdam (2006); *Migration & Development*, Museo Nacional San Jose Costa Rica (2006); Greenspace Festival, Valencia, Spain (2005); *Lisbon Photo Biennial*, Lisbon (2003); La Raffineri, Brussels (2003); *Fotodocs: Photography between Commission and Autonomy*, Museum Boijmans van Beuningen, Rotterdam (2002); TN Probe, Tokyo (2002); *Mutations*, Arc en Rêve, Bordeaux, France (2001); *Rotterdam Film Festival*, Rotterdam (2001); and *City Vision*, Seoul (2000). In 2000 he began a collaboration with architect Rem Koolhaas: the forthcoming book *Lagos: How It Works* is to be published in 2007. In 2003 he made the film *Lagos Live* with director/screenwriter Bregtje van der Haak. Cleijne occasionally collaborates with artist Ellen Gallagher; their 16mm film works have been shown at the Institute of Contemporary Art, London (2006); Art Unlimited Basel (2006); Freud Museum, London (2005); Museum of Contemporary Art, North Miami (2005); Fruitmarket Gallery, Edinburgh (2004); Henry Art Gallery, University of Washington (2004); and Studio Museum Harlem, New York (2003). He lives in New York and Rotterdam.

Cavemanman

Thomas Hirschhorn

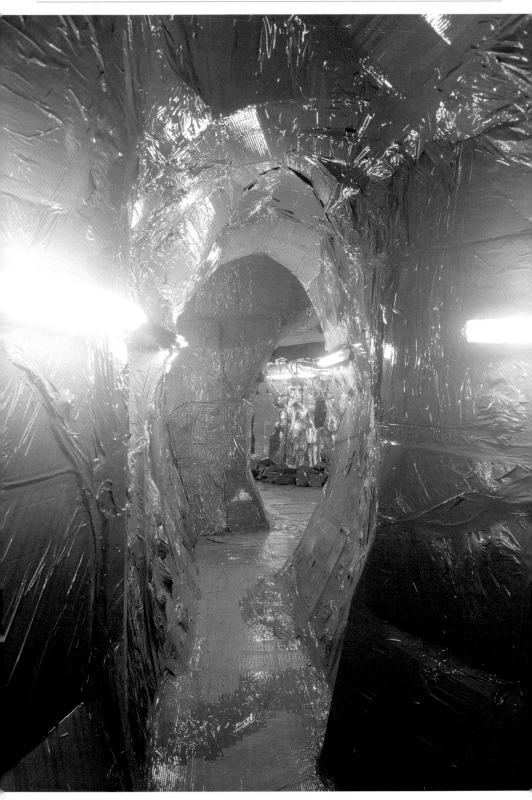

All images: Thomas Hirschhorn *Cavemanman* 2002

About Cavemanman

A series of e-mail conversations between Thomas Hirschhorn and Philippe Vergne, June–July 2006

I refuse this kind of absurd hierarchy between graffiti and historic artworks.

Philippe Vergne: I would like to approach our discussion about *Cavemanman* (2002) as an archaeologist or a speleologist would, looking around and trying to identify where I am and what I am looking at. Would you please tell me the nature of the elements that I am encountering in the cave, and maybe first, why a cave? In the source material you have shared, Lascaux appeared, tunnel constructions for train or highway, terrorist hideouts, and so on and so forth. Caves have a very mythical quality—is that what you were interested in?

Thomas Hirschhorn: One of my starting points for *Cavemanman* was the fact that recently a young man sprayed a football club slogan on the walls of a prehistoric site in France and was sentenced for destroying it. I refuse this kind of absurd hierarchy between graffiti and historic artworks. I accept a 30,000-year-old drawing on a wall as much as today's wall spraying. Didn't the Lascaux painters use the wall as support of expression as well? I am not interested in speleology or in archaeology, and I am not even interested in the history of caves or in the accumulation of cultural values.

The reason for me to give *Cavemanman* the form of a cave is because a cave is a nonhierarchical space. There is no hierarchy between the past and the present, between the passing of time, between the official and alternative histories. There is no hierarchy between the things that I can find in a cave because I don't know if they are old, if they are prehistoric, if they are fake, if they are stolen and left behind by looters, or just

left by tourists or some other occupants as rubbish. Everything in the cave has the same importance or can have the same importance; the real importance is what is important to me. I refuse that someone else decides about making something important in my place.

Lascaux II is as fascinating as Lascaux I and who can certify that Lascaux I is the real one? In an inhabited cave you can encounter a lot of elements, which are all layered leftovers of previous use. A cave is not a geographically specified space; all over the world there are caves. A cave implies universality. I am interested in universality and a cave is a form for a real universal space. I am not interested in the mythical quality of a cave; I am interested in the fact that the cave is a non-architectonic space. No architect, no interior architect, no designer, and no design is needed. A cave can be suitable for anything and everybody; it's a nonexclusive space. I am not interested by the cave as a natural place but as an organic space, a skin. A reversed skin. A cave exists also as an empty space, as a non-used space, and I like to think of all the existing undiscovered caves. The real Lascaux cave remains undiscovered.

PV: Then would you describe what and who inhabits the cave? You mentioned a reclusive philosopher. Why reclusive? Is that a form of escapism?

TH: The title of my work is *Cavemanman*, not *Caveman*. It's not about a singular person, it's about the Other. I am interested

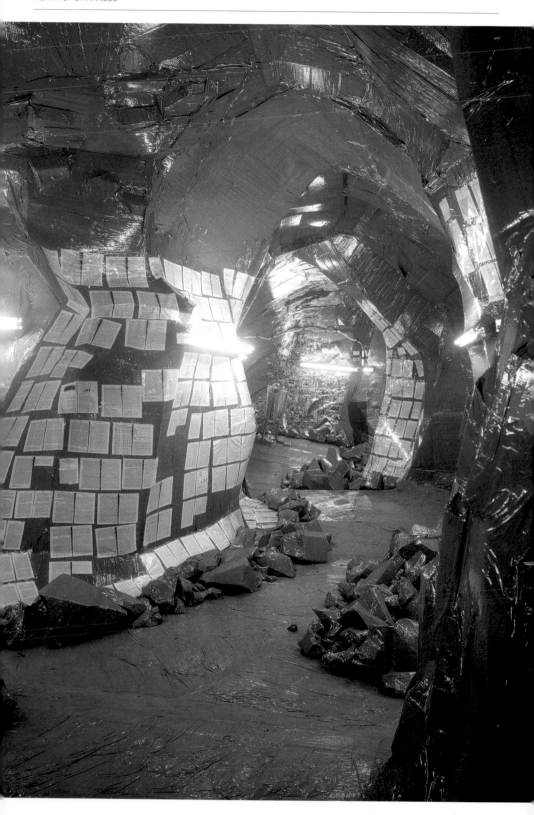

A cave belongs to everyone; there are no specific occupants, and the inscription on the walls of *Cavemanman* says: 1 Man = 1 Man.

in the question of the Other. I want to agree with the Other—not understand the Other and not approve of the Other—but agree. This seems to me one of the problems of today. How can I agree without neutralizing the Other? A cave belongs to everyone; there are no specific occupants, and the inscription on the walls of *Cavemanman* says: 1 Man = 1 Man. All generations of occupants and all motivations of occupants are equal. All hypotheses are possible. The cave is a space of the possible. *Cavemanman* wants to be a mental space. This space is in fact the brain. The brain is a space that can be filled and inhabited by thinking.

In *Cavemanman* I referred to philosophy because I love philosophy; I love "pure" philosophy, the philosophy that works on concepts that go beyond my immediate understanding. I need philosophy. I do not need philosophy for doing my artwork, but I need philosophy as a human being, as a man. I love the philosophy that I can try to touch, that I can try to reach as I can try to reach an artwork beyond understanding. I like the idea that Philosophy is Art. I love philosophy that confronts the big questions. This is not escapism nor exclusiveness, but it's the resistance against particularism, any particularism. The Resistance used tunnels. I am interested in tunnels and I am interested in tunneling. Doing tunnels is finding the way to the light. I believe in equality, the absolute equality, and I want to stay non-resigned, I want to stay disobedient, I want to stay

non-reconciled, and I want to agree with the world I am living in.

PV: In the light of your second answer, I am curious to know how you would define the Other for yourself.

TH: To me, the Other is my next, my neighbor. The Other is what is unfamiliar to me, what is strange to me, what I cannot understand and what I am afraid of. The Other is also what is remote and close at the same time; the Other is the absolute neighbor. The Other is the unexpected but it is not part of me; it's not myself. That is the difficulty—particularism is the less difficult, the expected, the predetermined, the conformed, and it is me as well. In experiences of artwork in public spaces, the Other means the absolute will to include, to work for—and not to exclude. What I call the Other is the assertion of this possible audience.

With my work I try to confront Artlovers, Artconnoisseurs, other Artists, Artcritics, Arthistorians, but I also want to confront the Other. I think that art—because it is art— can create the conditions for confrontation or direct dialogue with the Other, one on one. In this sense, art has a political meaning. Art escapes the control, the control of myself—the artist—and by doing this, art has the capacity to reach the Other. This is the miracle of art. I learned from doing projects such as the *Musée Précaire Albinet*, the *Bataille Monument*, or the *Deleuze*

If art has a power, then it is the power to be universal!

Monument[1] that the Other is what I have to agree with—and it was one of the most important experiences for me. I had to agree with the Other because I chose him and his neighborhood, and made my artwork with him in his space. Agreeing with the Other means "working politically" with confidence in the tool "art"—which has its own logic and strength. Working politically means working without cynicism, without negativity, and without self-satisfied criticism.

PV: You mentioned universalism and particularism. Don't you think that a notion such as universalism associated with a resistance to particularism could be philosophically dangerous? And by embracing the Other, you might be already embracing a particularism.

TH: I am not a philosopher; I am an artist. I am not doing philosophy. My work, my obsession, my problem but also my goal—as an artist—is to give form, to assert form, and to make assertions only through form. What is dangerous is to fall into the trap of refusal to give form, and what is *really* dangerous is to accept the idea of particularism in forms—instead of the universal form. If art has a power, then it is the power to be universal! I want to give a universal form. I want to fight the tendency to avoid giving form. Particularism is one of the topics that avoids confronting the question of form. Every time particularism issues occur in relation to art, I witness that it works against form, against my own form. I myself feel sometimes ridiculous in giving form, but I think it's up to me as an artist to stand up for this ridiculousness, and I am not afraid to confront this ridiculousness of the form. I want to take the risk of doing a universal

form in all its incredible fragility but also in its beautiful power. To me, embracing the Other, reaching the Other, confronting the Other, being in dialogue with the Other means trying to embrace, to reach, to touch, to confront the whole universe. I am in one universe, we are all in the same one universe. In order to touch the universality, I try to be free with what comes from myself, with what only comes from me—without regard to any particularism. I want to struggle with contradictions and paradoxes, I want to fight in the chaos and unclarity without neutralizing the Other or myself, and I do not want to be neutralized by particularisms. A universal form does not want to neutralize; it is confident in its own freedom.

PV: I would like also to pick up on the notion of resistance. Do you consider yourself a resistant, and do you think art should be disobedient or at least subversive? Are you subversive yourself? And coming from graphic design, do you think art is the best channel for subversion? I am asking these things in regard to your statement, "I want to agree with the world I am living in," which seems to contradict your other statement, "I want to stay non-resigned."

TH: I think that art is resistance, that art as art is resistance. Yes, I believe this! Art is all the time resisting the dictatorship of economic, cultural, social, and religious facts. I am not saying and never said that I am subversive, and I never said that I am a resistant. It's wrong and pretentious to claim this because subversion and resistance are not to be asserted. It's not a theory—it's something to improve, to work out. It is wrong because it's not me who is resistant, it's

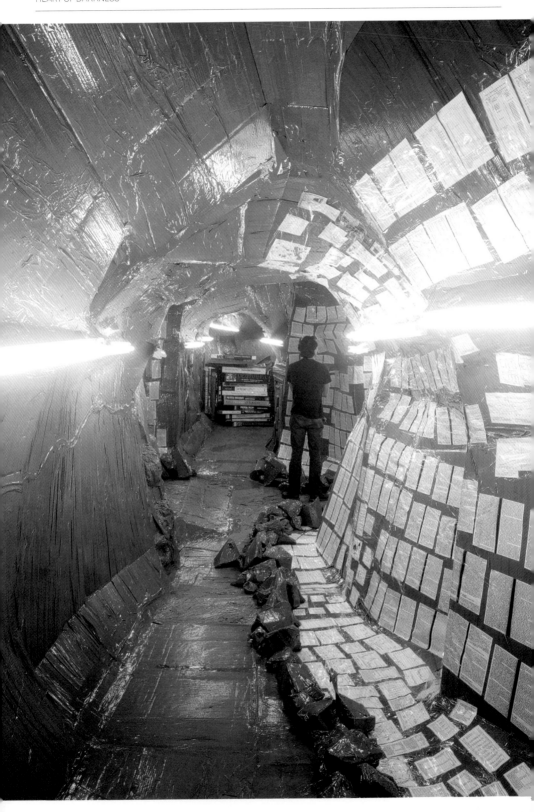

A Guide to the Contemporary Commonwealth
W. David McIntyre

Noam Chomsky Class Warfare

NOAM CHOMSKY Deterring Democracy

A TESTAMENT OF HOPE
THE ESSENTIAL WRITINGS AND SPEECHES
OF MARTIN LUTHER KING, JR.

JUSTICE SECOND EDITION Tom Campbell

Touraine Can We Live Together? Polity

Lovejoy TRANSFORMATIONS IN SLAVERY CAMBRIDGE

POLITICAL IDEOLOGIES AN INTRODUCTION
ANDREW HEYWOOD

BARRY CULTURE & EQUALITY

POLITICAL THEORY
AN INTRODUCTION ANDREW HEYWOOD

Oppression and Liberty
Simone Weil

Globalization Jan Aart Scholte
a critical introduction

THE COMING OF GLOBALIZATION

RETHINKING MULTICULTURALISM

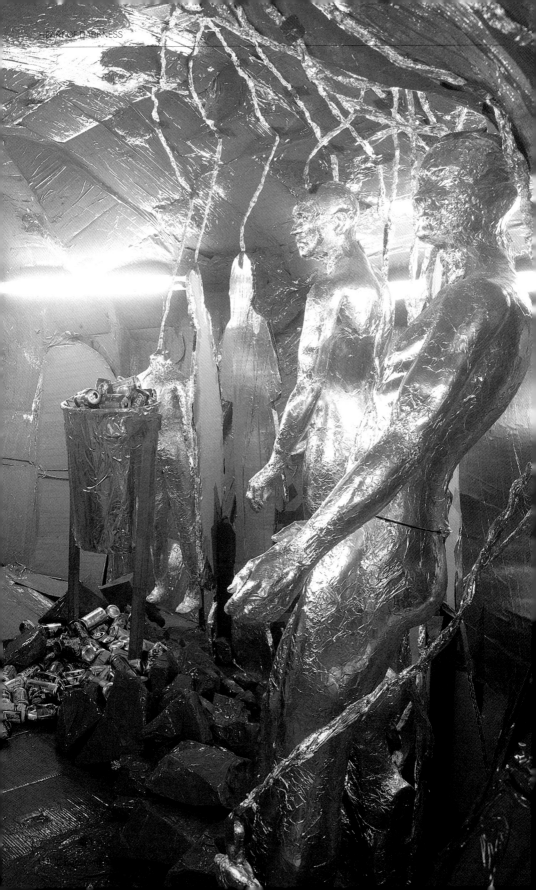

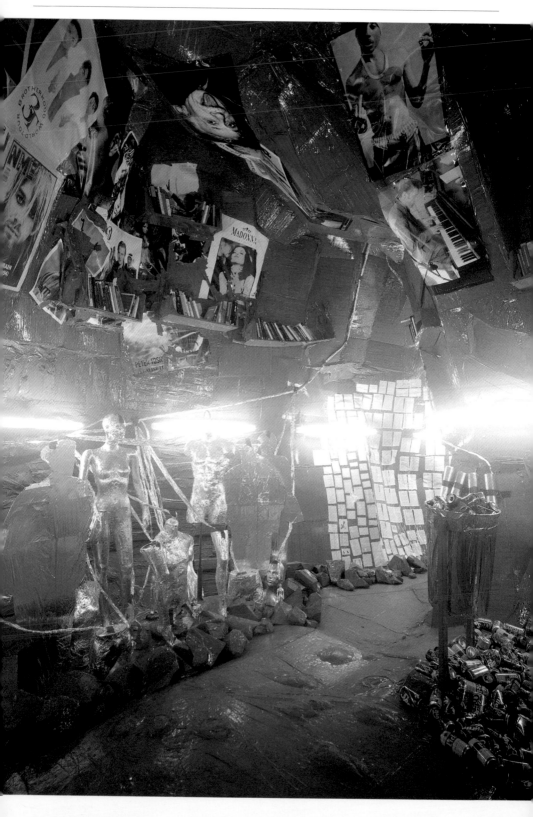

To agree means trying to act in the reality and trying to fight reality in order to change it.

not the artist who is subversive; it's art that resists and it's art that can be subversive! It's not art that is disobedient, it's me. It's also pretentious because the fight, as an artist, to work with the market—not for the market and not against it—is never won; this fight has to be made every day. To stay disobedient, not resigned, and non-reconciled, as I said, means to act with passion and headlessness. This is very important to me, and this is not in contradiction to what I said: "I want to agree with the world I am living in." To agree does not mean to approve of or agree with everything, nor to consent. To agree is an enlightenment, it's a gift, it's a tool, it's a weapon. To agree means trying to act in the reality and trying to fight reality in order to change it. I am sure that only when I agree will I have a chance to change reality. Not to agree means dreaming or escaping; to agree means going beyond theories and facts. Agreeing means acting by taking responsibility about everything. Agreeing also means to be responsible for what I cannot be responsible for. Art is the tool to take over this responsibility. To me, art is a tool to confront the world, the reality and the time I am living in. And this tool, art, is especially needed for work in public spaces—where I really have to agree with reality.

PV: You mentioned the "fragility of a universal form." I am interested in these notions. My understanding is that over the past fifteen years you have identified a form, or a language, that brings together on one hand a fragility or a modesty of means and material, and on the other hand an incredible and rare ambition. Would you please talk about the nature and importance of the materials you use? Would you consider that your work is, to quote philosopher Jacques Rancière, "*une machine de vision*" [vision machine] that offers an alternative to the consensual "*machine de pouvoir*" [power machine]?

TH: Yes, I did say there is fragility but also power! Fragility is never powerless, because isn't it a sort of resistance to power? I use "fragile" materials from everyday life; I try to avoid working with "arty" ones. I work with what everybody knows and uses, what everybody recognizes as poor materials with no real value and that don't want to intimidate—that's why I choose them. Power comes from the decision to use them. The fragility comes from my way of working, all hand-made, almost completely anachronistic today! Making something hand-worked and self-enlarged does not mean it is important. Very big doesn't mean very important, but it means being committed, and simultaneously enlarging makes the thing empty. The commitment and the emptiness together remove the meaning. I suggest another meaning— a different meaning. This is what interests me. I try to give meaning to the decision of enlarging work! This is fragility, this is assertion, this is headlessness, and this is not power-play in blowing things up. I think there is a challenge about the question of materials: I need to love the material I am working with, and this love is an egoistic, autistic, selfish, and exclusive love. If I did not love the material, it would mean giving it importance. I don't want the material to be important as such, but I believe that the love of the material I am working with can make it reach universality, a universality with "importance," because I am the one who

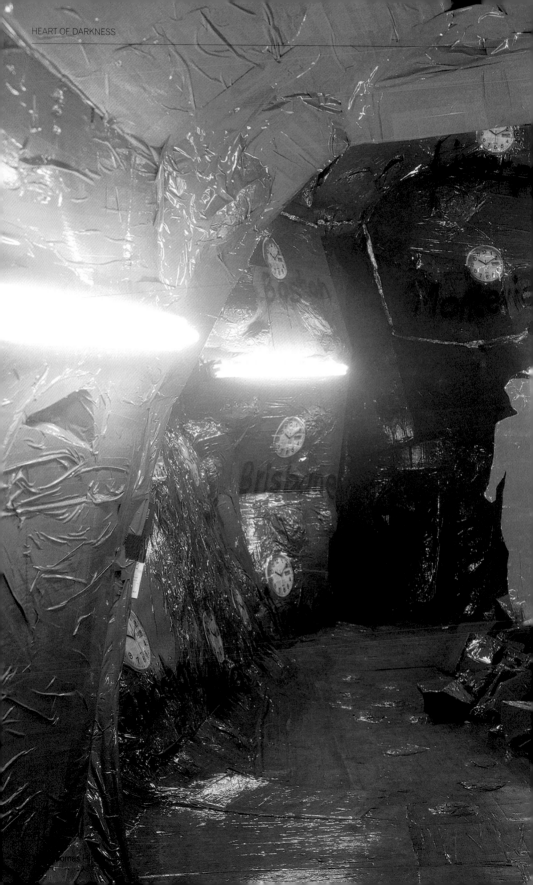

Thomas H

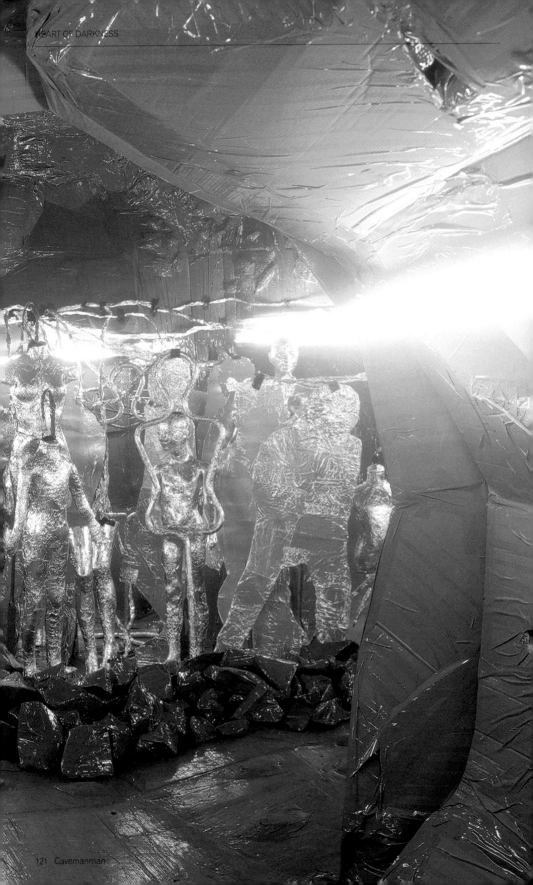

Beauty is important to me, but I do not accept reducing it to an aesthetic taste.

first gave it importance. I understand universality as hope, as a machine to hope, as the tool to construct a world in equality and freedom, and as a weapon to fight resentment and hate.

PV: Among the elements that constitute your "form," you often use very brutal images—cruel, powerful images from the media. I'm thinking specifically about your 2006 exhibition in New York (*Superficial Engagement*) or your series of drawings and collages such as *Blue Serie* (2001). These images are truly fascinating and repulsive at the same time. When looking at them, one has to acknowledge what philosopher Julia Kristeva named "powers of horror" and how they could trigger a form of voyeurism. But in the meantime, they seem to have a cathartic or healing power (this was quite clear to me through their confrontation with the works of artist Emma Kunz).[2] Where do you stand in relation to these images, and what is your intent or expectation regarding the way the viewers approach or experience your work?

TH: How could I have expectations on people's approach to my work or their reaction to it? I do not understand comfortable and luxurious oversensitivity or hypersensibility; these are not compatible with art. Oversensitivity and hypersensibility have to do with self-protection and with self-enclosure, and perhaps with narcissism. I am not interested in this. There are so many people in the world who don't even have the choice of being sensitive or not. When hypersensitivity and oversensibility become a way of excluding problems, I do not agree, and I do not agree about personal reaction. Such personal reactions are corrupted by the political power interested in not showing these kinds of brutal, cruel, and powerful pictures, as you named them. I think that oversensitivity and hypersensibility can turn into an incapacity to act. The images you mentioned come from our own world. I do not use them for their facts—I am not a journalist—and I am not interested in who?/why?/where?/who is the victim?/who is the torturer?/who is guilty? I want to look at these images with no information and I want to say: every wound is my wound! The images that I use in my work are an attempt to confront the violence of the world and my own violence. I am part of the world and all the violence of the world is my own violence, all the hate is my own hate. I am not interested in voyeurism. I really think that the term "voyeurism" makes no sense anymore in the world today. I am not interested in escaping the cruelty of the time I am living in. I want to put the whole world into my work. I want to put everything in, the whole universe. I want to express the complexity and the contradiction of the world in one single work. I want to express the world that I am living in—not the whole world as entire world but as a fragmented world.

I do not want to make fascinating or repulsive work; I want to do beautiful artwork. What is beautiful to me is what is engaged and what has its own energy. Beauty is important to me, but I do not accept reducing it to an aesthetic taste. Where do I stand? I really hope I answer this question through my artwork first. What do I want? What is my position? I think these are the fundamental questions for an artist. As an artist I have to start from myself. I am my own source; I have to work

only from what comes from myself. This does not mean cutting myself off from the surrounding world, but confronting it with my own artwork, staying lucid about control of all kinds of information. I do not need information for making artwork, as my work is never about information or opinions. Doing artwork is not developing argument, doing journalism or politics; doing artwork is not working with facts or against facts. With my work I want to reach, touch History beyond the historical fact. In art there never is disinformation! Doing artwork is not communicating about problems but asserting forms—doing art is trying to touch truth. I want to act. I want to touch the truth. ■

Notes

1. Many of Thomas Hirschhorn's projects have taken place outside conventional gallery or museum settings and have involved interactions with the communities in which the artist is working. Along these lines, *Monument to Georges Bataille* (2002), named for the French writer, anthropologist, and philosopher, was conceived in a neighborhood in Kassel, Germany, during the exhibition Documenta 11. Built in collaboration with members of the community and run by them, the project functioned as a library, a bar, and a TV studio.

He created a precursor, *Monument to Deleuze* (2000), in the context of the French exhibition *La Beauté in Avignon* as a tribute to philosopher Gilles Deleuze. The sculpture was installed in a housing project in the suburbs of Avignon. A fragile architectural portrait of the philosopher, the edifice also sheltered a library in which his books were collected and made available to the public.

In 2004, Hirschhorn set up a satellite post of Paris' Musée National d'Art Moderne in Aubervilliers, the suburb where he lives and works. For eight weeks, the precariously constructed *Musée Précaire Albinet* displayed works by Marcel Duchamp, Kasimir Malevich, Piet Mondrian, Salvador Dalí, Joseph Beuys, Andy Warhol, Le Corbusier, and Fernand Léger, and housed a series of lectures, workshops, and communal meetings and meals with participants. *Musée Précaire Albinet* was built and operated with the help of the town's residents and a local art center, Les Laboratoires d'Aubervilliers. The artworks on view were loaned from the permanent collections of the Musée National d'Art Moderne and the Fonds National d'Art Contemporain.

2. A healer, researcher, and artist, Emma Kunz (1892–1963) lived in the German-speaking part of Switzerland. At a very early age, she demonstrated and used her unusual abilities of telepathy and prophecy, and as a healer she began to exercise her divining pendulum. In 1941 she discovered the power of the Würenlos healing rock that she named AION A. From 1938, she created large-scale pictures on graph paper. She described her creative work as follows: "Shape and form expressed as measurement, rhythm, symbol, and transformation of figure and principle."

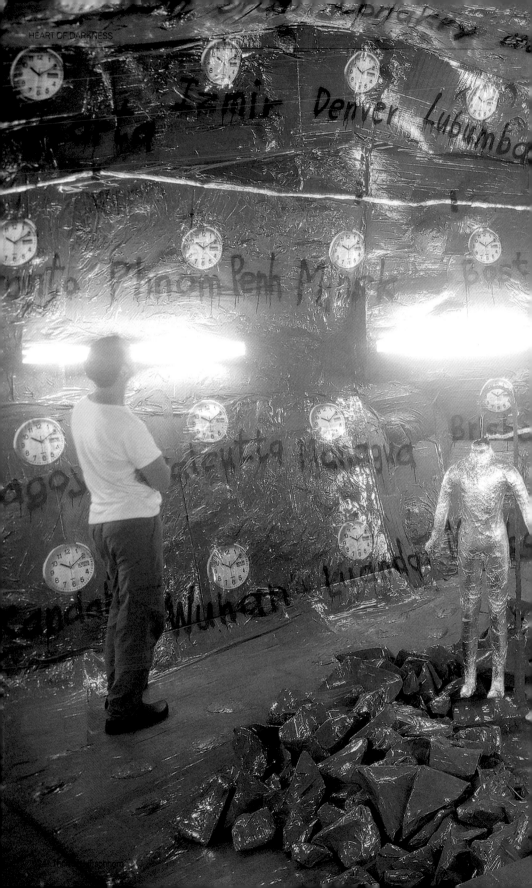

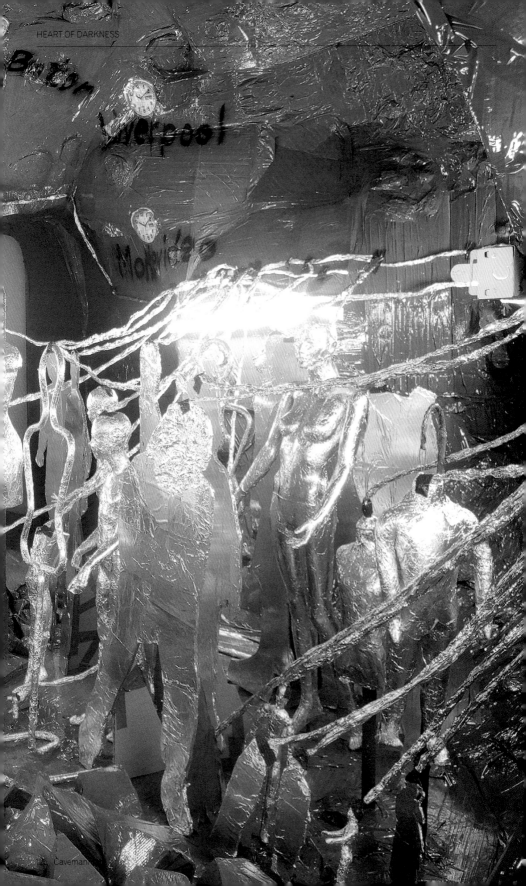

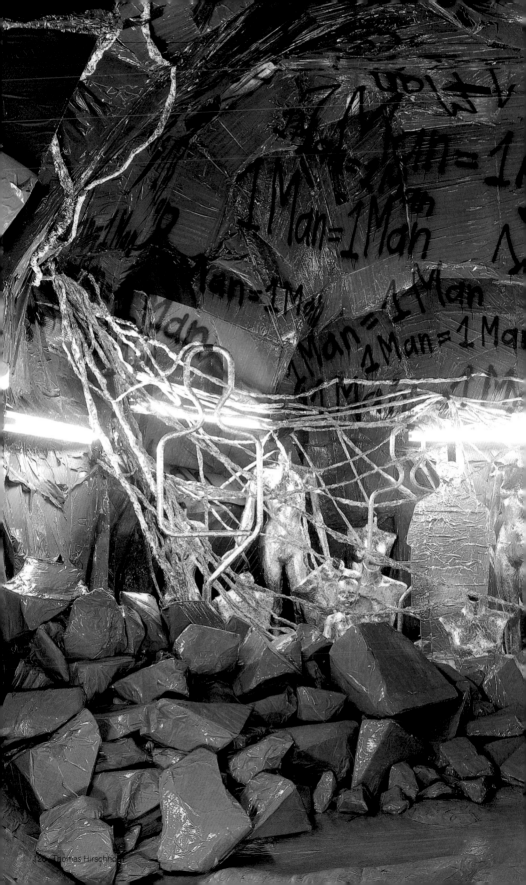

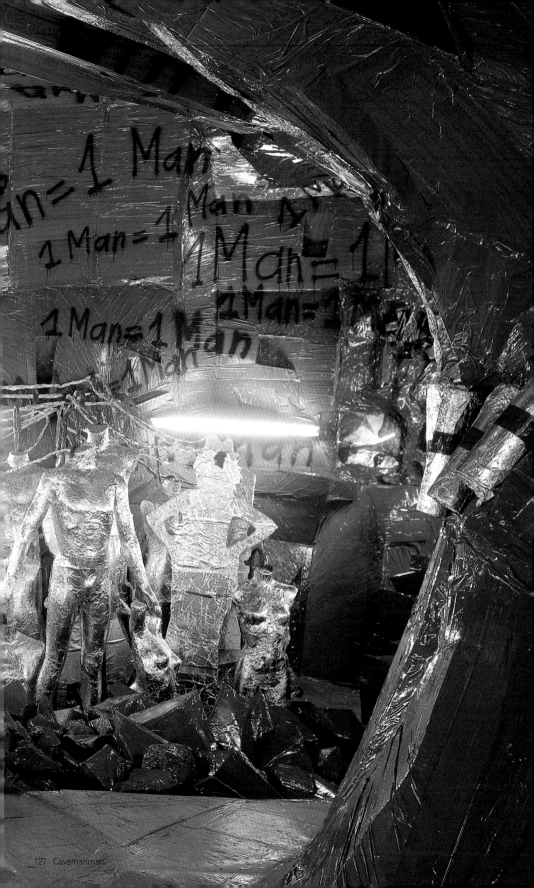

Thomas Hirschhorn
Born 1957, Bern, Switzerland
Lives and works in Paris

Selected Solo Exhibitions

2006
Thomas Hirschhorn: The Green Coffin, Alfon___ ___ ___,
Napoli, Italy

Thomas Hirschhorn: The Procession, Kestner Gesellschaft,
Hanover, Germany

Superficial Engagement, Gladstone Gallery, ___

2005
Thomas Hirschhorn, Pinakothek der Moderne, Munich

Anschool II—Thomas Hirschhorn, Museu Serralves—
Museu de arte contemporânea, Porto, Portugal

*Utopia, Utopia = One World, One War, One Army, One
Dress*, Institute of Contemporary Art, Boston; CCA Wattis
Institute, San Francisco. Catalogue.

2004
Swiss-Swiss Democracy, Centre Culturel Suisse, Paris

24th Foucault, Palais de Tokyo, Paris

Thomas Hirschhorn, Stephen Friedman Gallery, London

2003
Doppelgarage in der Schirn, Schirn Kunsthalle, Frankfurt

Chalet Lost History, Galerie Chantal Crousel, Paris

United States Miniature, Centro de Arte Contemporáneo,
Malaga, Spain. Catalogue.

2002
Thomas Hirschhorn, Arndt & Partner, Berlin

Cavemanman, Gladstone Gallery, New York. Catalogue.

2001
Restaurant Economics, Kunsthaus Zürich

Archeology of Engagement, Museu d'Art Contemporani de
Barcelona, Barcelona

2000
Thomas Hirschhorn: Jumbo Spoons and Big Cake,
Art Institute of Chicago. *Flugplatz Welt/World Airport*,
Renaissance Society, Chicago. Catalogue.

Exhibitions

___ ___ *Contemporary Painting and Global*
___ ___ ___ ___nin Centre for Contemporary Art,
___ ___ ___ipo, Italy. Catalogue.

2005
___ ___ ___nce: Art, Life, and the Tourist's Eye,
___ ___ ___London; Museum of Contemporary Art,
___ ___ ___ue.

___ ___ Georges Pompidou, Paris. Catalogue.

The Failure of Beauty/The Beauty of Failure, Fundacio
Joan Miró, Barcelona. Catalogue.

2003
Common Wealth, Tate Modern, London. Catalogue.

Utopia Station, 50th International Art Exhibition, Venice
Biennale. Catalogue.

2002
*Public Affairs: von Beuys bis Zittel: Das Öffentliche in der
Kunst*, Kunsthaus Zürich. Catalogue.

Documenta 11. Kassel, Germany. Catalogue.

2001
Parkett Collaborations & Editions since 1984, Museum of
Modern Art, New York. Catalogue.

2000
Protest & Survive, Whitechapel Art Gallery, London.
Catalogue.

Selected Bibliography

Buchloh, Benjamin H. D., Alison M. Gingeras, and Carlos
Basualdo. *Thomas Hirschhorn*. New York: Phaidon, 2004.

Curiger, Bice. *Short Guide into the Work of Thomas
Hirschhorn*. Exh. cat. New York: Gladstone Gallery, 2002.

Hirschhorn, Thomas. *Utopia, Utopia = One World, One
War, One Army, One Dress*. Exh. cat. Boston: Institute of
Contemporary Art, 2005.

Rondeau, James, Hamza Walker, and Okwui Enwezor.
*Thomas Hirschhorn: Jumbo Spoons and Big Cake, The
Art Institute of Chicago: Flugplatz Welt/World Airport,
The Renaissance Society at the University of Chicago*.
Exh. cat. Chicago: Art Institute of Chicago, 2000.